IMAGES
of America

SHELTER ISLAND

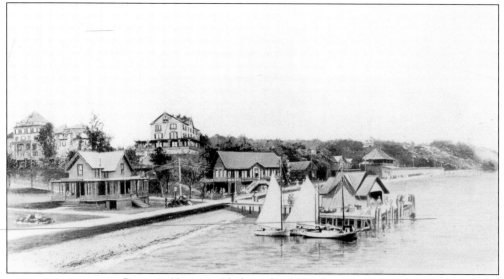

Prospect House in Shelter Island Heights, c. 1890

IMAGES
of America

SHELTER ISLAND

Louise Tuthill Green

ARCADIA
PUBLISHING

Published by Arcadia Publishing
Charleston, South Carolina

Printed in the United States of America

Library of Congress Catalog Card Number: 2008940190

For all general information contact Arcadia Publishing at:
Telephone 843-853-2070
Fax 843-853-0044
E-mail sales@arcadiapublishing.com
For customer service and orders:
Toll-Free 1-888-313-2665

Visit us on the Internet at www.arcadiapublishing.com

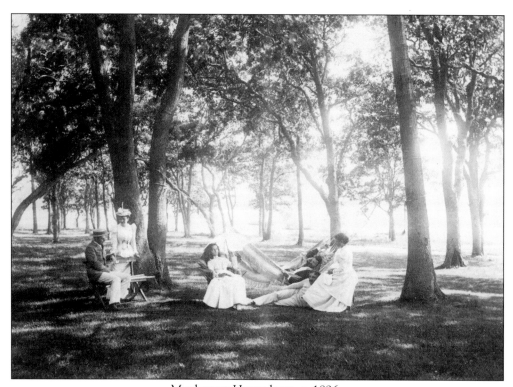

Manhanset House lawn, c. 1896.

Contents

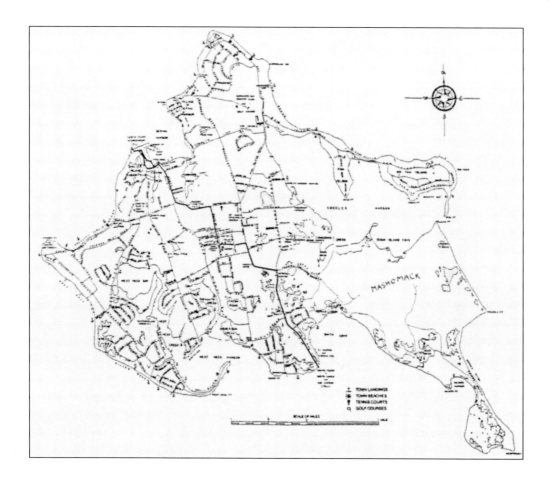

Acknowledgments

The content of this book was determined by the photographs which have been generously donated to the Shelter Island Historical Society by many individuals, organizations, and businesses.

I would like to thank the Shelter Island Historical Society's archival committee members Peggy Dickerson, Vera Anderson, and Keith Bourne for sharing their knowledge of Shelter Island history, as well as the society's collection of photographs, maps, and written material. I greatly appreciate the recollections of Marion Dickerson, Bo Payne and Frank Klenawicus. I would also like to thank Stewart Herman for his thorough research into local history which he has shared through his numerous books and articles.

I am especially grateful to my family. It is only through the help and encouragement of my husband Jason Green, my mother Jean Tuthill, and my sister Laura Tuthill that this project has reached completion.

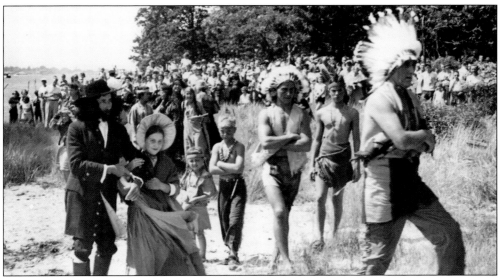

The 1952 Tercentenary Pageant. Nathaniel Sylvester and his young bride, Grissel Brinley, were greeted by the Manhanset Indians on the shore of Dering Harbor near Sunset Rock. Albert Dickerson portrayed Chief Pogatticut. Sylvester Prime and his daughter Mary played the parts of their Sylvester ancestors.

Introduction

The photographs contained within these pages and preserved in the archives of the Shelter Island Historical Society allow us to glimpse the people and events in our social, cultural, and economic history, as well as contemplate the changing landscape.

For many generations the Manhanset tribe inhabited Shelter Island, which they named "Manhansack-aha-quash-awomack," meaning "an island sheltered by islands." Pogatticut, or Yokee as he was more often called, was Grand Sachem of most of the tribes on Long Island, as well as the local chief. His brothers were sachems of the Montauk, Shinnecock, and Corchaug tribes, and his brother-in-law Checkanoe was a well-known interpreter between the Algonquin Nation and the colonists. There were strong ties between the island and its neighbors. The year was 1651.

Four merchants in the West Indies sugar trade bought Manhansack-aha-quash-awomack for 1,600 pounds of Barbadian sugar. They were interested in the island for its tall, white-oak forests. The wood was needed to make casks in which to ship sugar, rum, and molasses from Barbados to England and the colonies.

One of the sugar merchants, Captain Nathaniel Sylvester, chose to settle on Shelter Island. Slaves and hired workmen were shipped to his newly acquired land to build a suitable house for himself and his young bride-to-be, Grissel Brinley.

In the spring of 1652, the Sylvesters set sail aboard *The Swallow*, sailing from England by way of Barbados, toward their new home. They encountered a fierce storm off the North Atlantic coast. Their ship was wrecked and most of their household goods and furnishings lost, but the Sylvesters and their servants were spared and were soon able to complete their journey.

Henceforth, this isle of shelter was settled and its original inhabitants forced to relocate to the neighboring lands of the Montauk and Shinnecock tribes. The history of the town of Shelter Island began to unfold.

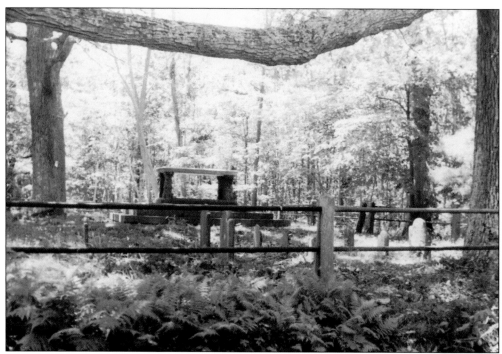

The Quaker Cemetery and Sylvester Monument. The earliest marked grave on Shelter Island is that of Jonathan Hudson, who died at age seventy-one in 1729. The marble monument, unveiled in 1884, is a shrine to the persecuted Quakers who sought refuge and also a tribute to the Sylvesters who afforded them shelter.

In memory of Louise H. Sutton
who lovingly shared with me
her knowledge and memories of our island heritage

One

The Settlers

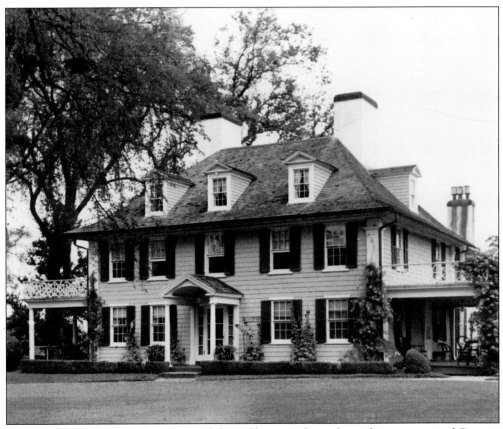

Sylvester manor, c. 1940. A sturdy wood-framed house with two large chimneys awaited Captain
Sylvester and his household in the spring of 1652.

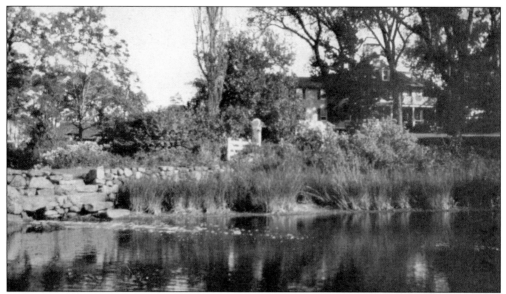

Sylvester manor, c. 1945. The present manor house was built in 1730 after a fire destroyed the greater part of the original house. Rough-hewn stone steps may be seen at the edge of Gardiner's Creek. Built by slaves, the landing appears as it did to the Sylvesters over three hundred years ago.

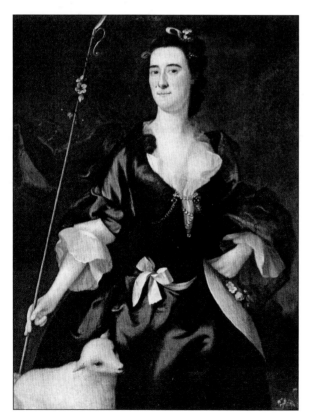

Mary Sylvester (1724–1794). The oil-on-canvas painting by Joseph Blackburn depicts the youngest daughter of Brinley Sylvester. Mary Sylvester married the prominent Boston merchant Thomas Dering in Newport, Rhode Island, where she was receiving her education. They moved into the manor house in 1760. (Metropolitan Museum of Art, Gift of Sylvester Dering, 1916, #16.68.2.)

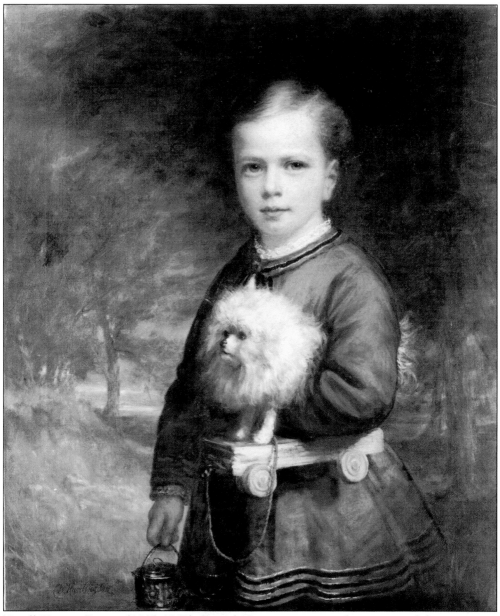

Nicoll Havens Dering (1865–1869). Daniel Huntington painted a portrait of the young son of Sylvester Dering and Ella Bristol. (Metropolitan Museum of Art, Gift of Sylvester Dering, 1916, #16.68.5.)

Sylvester manor gardens in the early 1900s. Miss Cornelia Horsford, pictured here beside the 1890s Asa Gray water garden, became proprietor of the manor in 1903. She recreated the early Colonial garden as she imagined it to be and tended the lovely roses and boxwood.

The garden steps, c. 1915. Steps leading from the upper to lower gardens were built at the turn of the century. Perennial borders, a Yellow Garden, and an inviting gazebo have been added to the extensive gardens by Mrs. Andrew Fiske, the thirteenth generation of manor gardeners.

Two

The Growing Community

Miss Annie's house in Mashomack, c. 1890. In 1695, William Nicoll bought a large tract of land at Sachem's Neck from Giles Sylvester. William Nicoll II settled on the island, taking an active roll in organizing the town. In the spring of 1730, he became the first supervisor, governing the town of twenty families. The Victorian mansion built by Miss Annie's brother, Dr. Samuel Nicoll, was destroyed by fire in 1947. Dr. Nicoll resided in the Bass Creek Manor House. The 2,039-acre Mashomack Preserve is now a part of the Nature Conservancy.

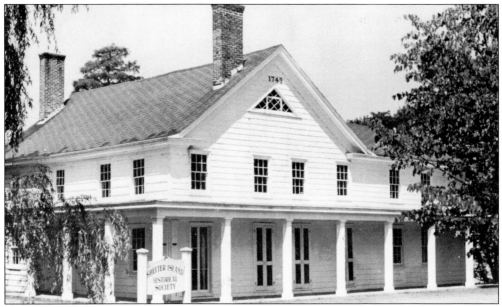

Havens House built in 1743. James Havens, a sea captain and patriot, named his 1,000-acre family farm "Heartsease." The white, shingled farmhouse served as a town meeting hall, school, tavern, post office, and store through the years. It became the home of the Shelter Island Historical Society in 1968.

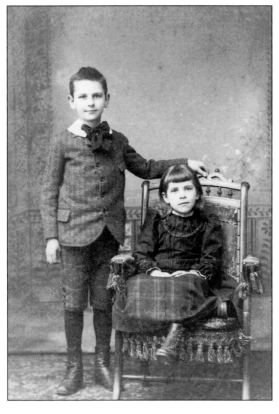

Ralph and Elloine Havens, 1891.

Southeast bedroom, Havens House. Abigail Field displays a child's patchwork quilt in this 1972 photograph. Many of the artifacts and furnishings in Havens House were donated by island families.

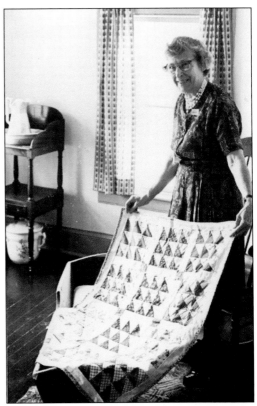

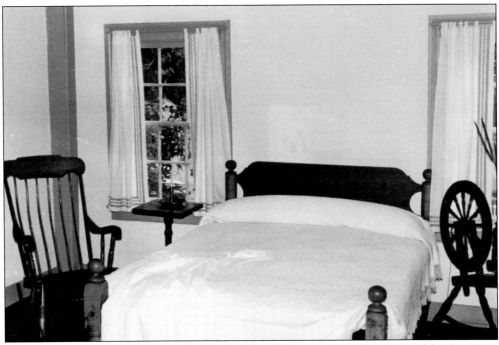

Middle bedroom, Havens House. The Shelter Island Chapter of the Daughters of the American Revolution recreated rooms from the past in the historical house.

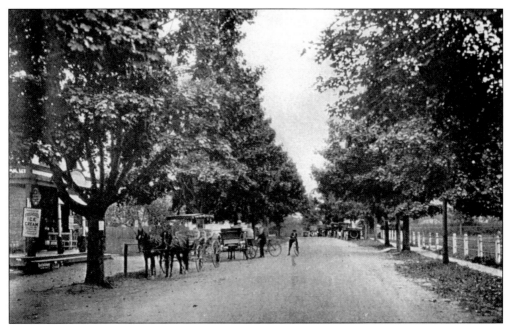

State Road at the turn of the century. State Road, also named North Ferry Road, passes through the center of the island. The dirt road was flanked by Lester's Ice Cream Store (Carol's Luncheonette in more recent years) and the fenced school yard.

King and Manwaring Garage, c. 1936. The auto repair shop, originally the wheelwright's shop, was next door to the ice cream store.

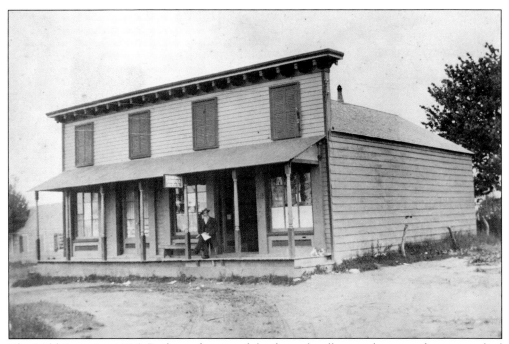

The "Old Store," *c.* 1885. Built on the site of the first schoolhouse, the general store supplied many of the island's needs. It housed the post office, telegraph office, and lending library. This building, located to the east of Duvall Road, was destroyed by fire in 1891.

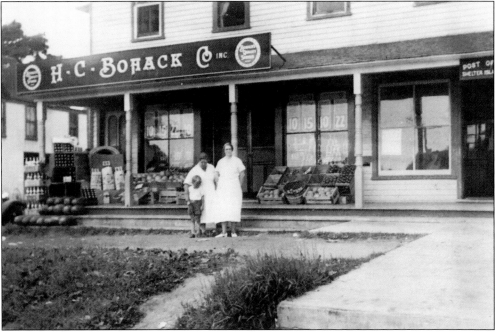

Duvall's Store, *c.* 1930. Postmistress Eleanor Griffing (right) is pictured in front of the Duvall grocery store, which was built in 1893. It was here that the townsfolk gathered for conversation or a game of dominoes. In 1946, George Walsh Sr. opened George's Market, which has remained in business for over fifty years.

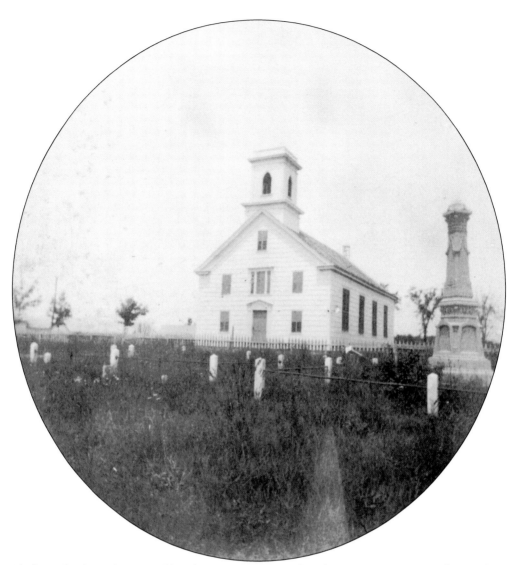

Shelter Island Presbyterian Church, c. 1891. Soon after the town was organized, Jonathan Havens Jr. donated land for a meeting house and burying ground. The first church building was constructed in 1743. Brinley Sylvester was overseer of the work. Captain Samuel Lord, owner of Lord's Shipyard and the heavily wooded acres of Menantic, and Sylvester Dering of the Sylvester manor provided the framework timbers. The building was destroyed by fire in 1934, and the present Presbyterian church was constructed on the site.

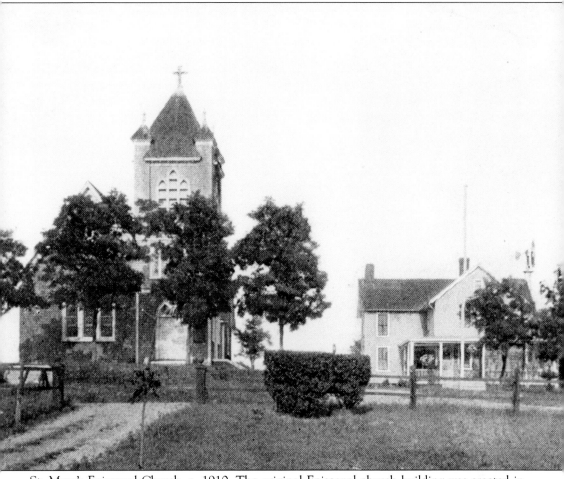

St. Mary's Episcopal Church, c. 1910. The original Episcopal church building was erected in 1873. Sunday afternoon worship service had been held in the town hall prior to that time. In 1887, a rectory was built for use by visiting clergymen. During a severe storm on July 26, 1892, a bolt of lightning struck the steeple, engulfing the structure in flames. The present-day "St. Mary's" was quickly built and was named in memory of Matthias Nicoll's wife, Mary Alice.

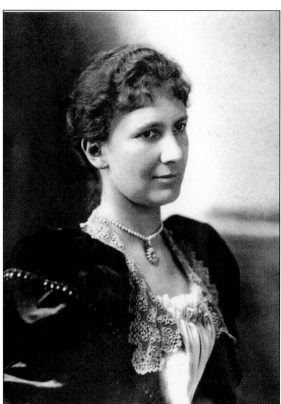

Cornelia Horsford, c. 1895. Miss Horsford was the daughter of library founder, Eben N. Horsford. She served as Shelter Island Public Library's first president and as a trustee for many years. Mrs. Helen Kinne first held the position of librarian.

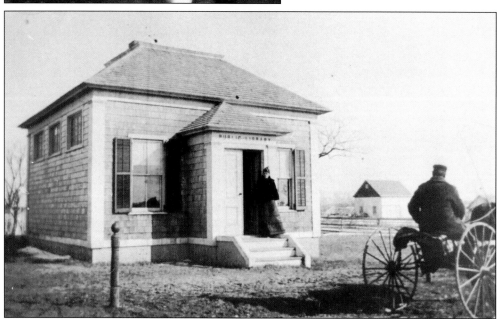

Shelter Island Public Library, c. 1895. Professor Horsford founded the library in 1885. Books were kept in the "Old Store" stacked on shelves that had previously held shoes and boots. When the store burned down, funds were raised to build a 16-by-20 foot library on a lot by the mill which had been given for that purpose by Lillian Horsford Farlow.

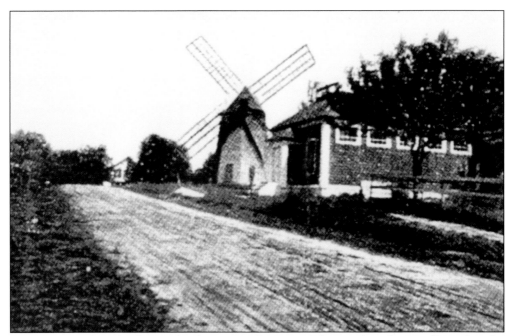

The library and windmill on School Street in the 1890s. The weathered gristmill stood in the center of town until 1932, when it was moved to a small field on the property of Sylvester manor. It may now be viewed from Manwaring Road.

Willis Worthington, c. 1920. Following a successful fund-raising drive by the library's Research Club, a wing was added to the small library building in the early 1900s. Known as the Worthington Museum, it housed naturalist Willis Worthington's collection of shells, bird eggs, stuffed birds, reptiles, and mammals, and also Native American artifacts.

Isaac Downs' house, c. 1910. Ike Downs was photographed in front of his home on Cartwright Road. He is holding a splint basket which he crafted from strips of white oak, which he soaked in the swamp behind his house until they became supple and easily woven. Ike supplied baskets for farming, fishing, and household chores to the community.

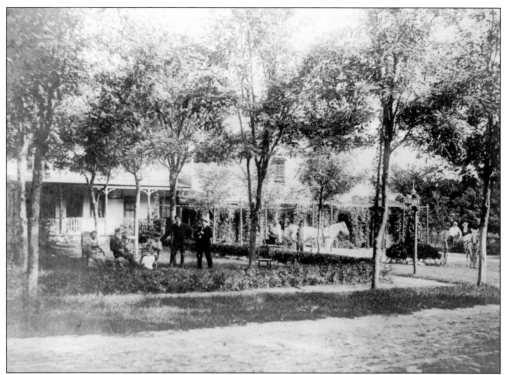

Meinhardt's Hotel, c. 1900. The large airy rooms and wide porches of George Meinhardt's hotel made it a welcome lodging. In 1906, the two-story guesthouse on Stearns Point Road was bought by Louis Behringer, chef of New York City's Waldorf Astoria and the Prospect House in the Heights. He renamed the hotel The Shelter Island House.

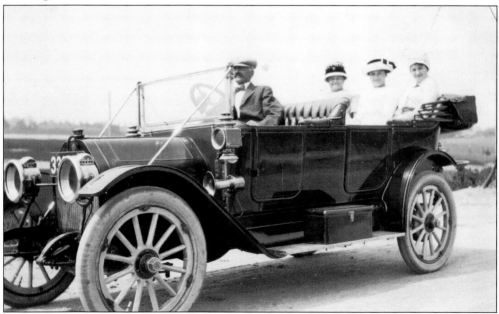

Out for a drive in 1912. Fred Dickerson took his wife, Maggie, and his sisters for a ride in the family automobile.

Louis' Beach, c. 1906. Crescent Beach was known as Louis' Beach during the first half of the twentieth century. Louis Behringer built a dock each year for his Shelter Island House guests. The dock was taken apart in the fall and stored behind the hotel. The popular bathing beach was also the location of Jack Wroble's swimming classes for over fifty years.

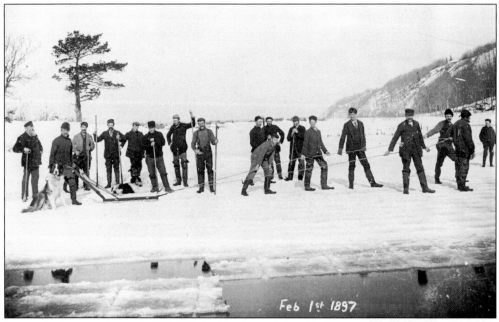

Ice cutting in the winter of 1897. Weck's Pond, nestled behind Louis' Beach at the eastern end of Shore Road, was one of the fresh water ponds which supplied ice for harvesting. The thick ice was scraped, scored, and sawed into blocks for storage in an ice house. Fresh Pond and Ice Pond were also harvested.

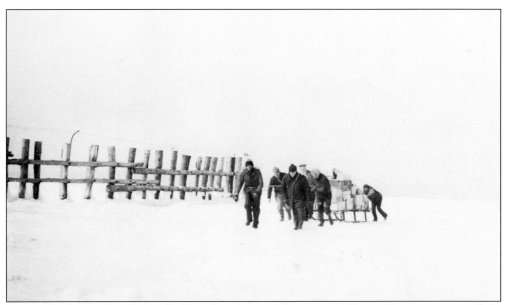

Delivering the mail in 1934. The bay often froze solid in winter allowing horses, wagons, sleds, ice boats, and eventually cars to cross to the mainland and back with news and supplies. It was reportedly, "A thrilling experience which took about an hour one way."

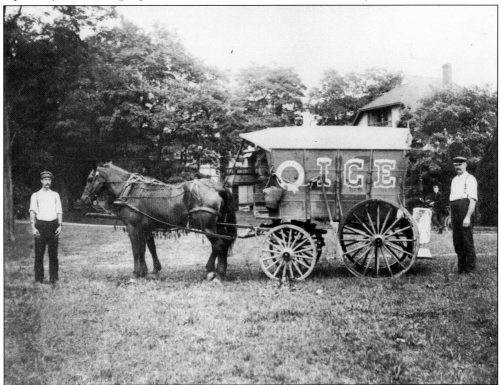

The ice wagon, c. 1909. Mortimer Rackett and Ed Treadway delivered blocks of ice to many island homes. Sawdust, straw, and seaweed insulated the ice stored in ice houses, making it possible to stock ice boxes through the warmer months.

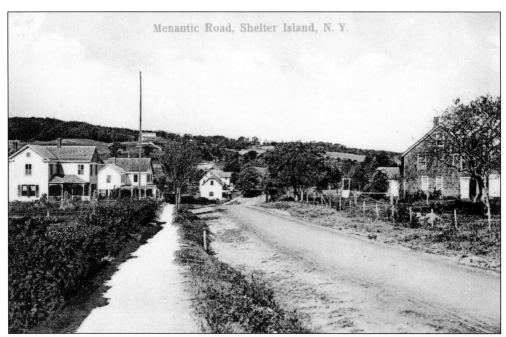

Menantic Road, *c.* 1900. Menantic Road was laid out in 1877 to connect the Heights with the rooming houses and homesteads in the Menantic area. The houses pictured from left to right belonged to Fisher, Dawson, Ketcham, and Havens.

The Ketcham house, built in the 1880s. The old Ketcham homestead and grocery store still stand on the corner of Menantic and West Neck Roads.

Three

The Heights

The gateway to the Heights, c. 1900. A vine-covered arch at Ketcham's Corner marked the entrance into the Heights. Early in the nineteenth century, Squire Frederick Chase purchased the high bayberry- and blackberry-covered hills in the northwest part of the island. He named the area Prospect and dreamed of it becoming an idyllic city of sobriety. In 1871, the descendants of Squire Chase sold the 300 acres to a group of twenty-four clergymen and laymen from Brooklyn, who incorporated the property into the Shelter Island Grove and Camp Meeting Association of the Methodist Episcopal Church.

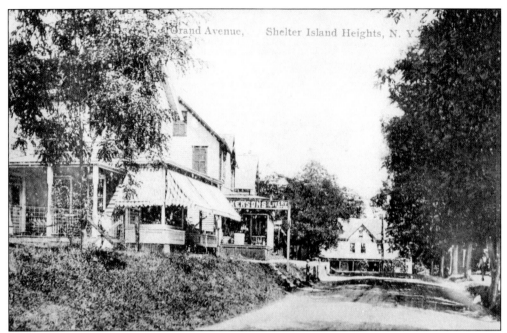

Grand Avenue in the early 1900s. In this photograph which looks north along Grand Avenue, the first store pictured belonged to Nathan Dickerson in 1916, as did the livery next door. The porch and roof of G. R. Havens' general store may be seen to the right. The large building on the corner of Grand and Chase Avenues was built by Squire Chase.

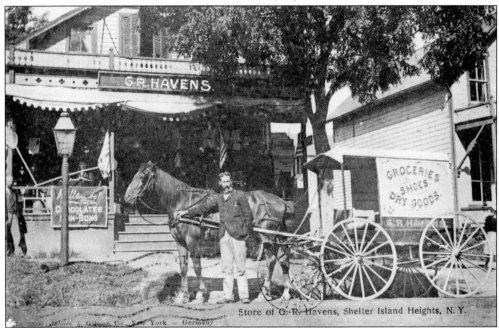

Havens General Store, c. 1912. Many young lads delivered groceries for George Havens, whose general store supplied food and all kinds of household goods. Moxie and Coca Cola were a favorite drink of the delivery boys. Dawson's Meat Market would soon occupy the store to the right.

Group in front of the Heights Post Office in 1893. Phoebe Griffing (left) and Charlotte Deale (right), the daughters of Scudder Smith, pose with Charles H. Smith Jr., who was elected to the office of town supervisor in 1912.

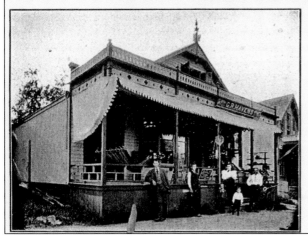

G. R. HAVENS

DEALER IN

Choice
Groceries

Dry Goods, Shoes, Boots, Notions.

Crockery, Hardware, Tin and Wooden Ware

229 GRAND AVENUE

Shelter Island Heights, N. Y.

Havens General Store advertisement, c. 1912. The Heights was an active business center in the early years of this century, but electric lights did not illuminate the stores or the streets. Kerosene was the available lighting fuel of the day. Lamplighter Fred Hopper was a familiar figure as he pulled his wagon filled with kerosene, wicks, and cleaning rags through the streets each morning. Equipped with a small ladder, he cleaned and filled each lamp. In the evening, he would follow the same route, lighting the trimmed wicks.

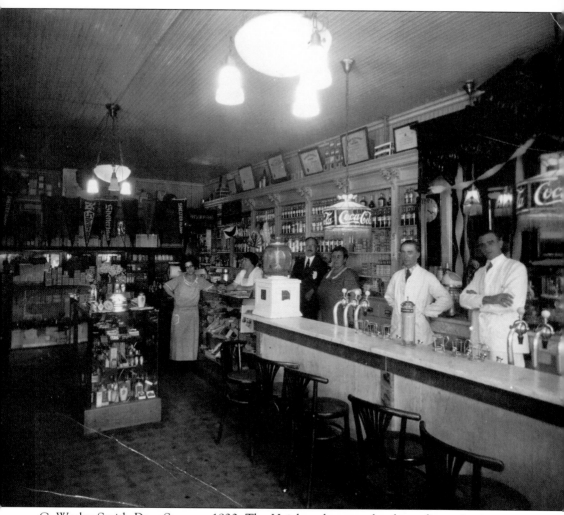

C. Wesley Smith Drug Store, *c*. 1920. The Heights pharmacy has been dispensing ice cream sodas and prescriptions for close to a century. Founded by Heights Superintendent C. Wesley Smith, the island's only drug store opened a branch at the bustling Manhanset House. An advertisement stated, "Prescriptions our specialty. Ice cream sodas and Frappe with fresh fruit. Huyler's Candy received fresh daily. Souvenirs of Shelter Island." Pictured, from left to right, are: Rose Jaffe, Marie Strobel, C. Wesley Smith, Alice Sherman, Norman Davis, and Henry Jennings.

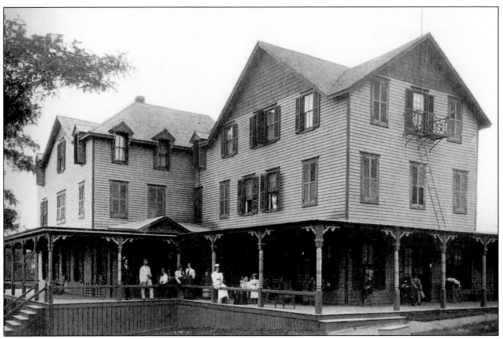

The Bayview Inn, c. 1900. Originally known as The Restaurant and later as Chequit Inn, the Bayview Inn was built as a community dining hall for the Shelter Island Grove and Camp Meeting Association.

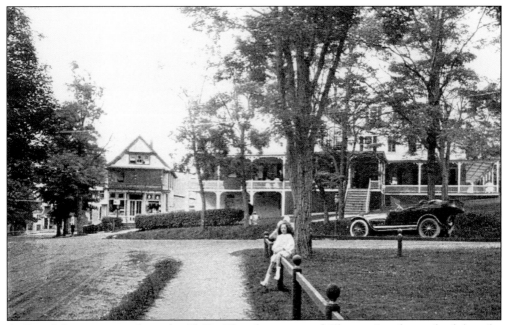

A Grand Avenue scene from the 1940s. The pharmacy and Chequit Inn form a backdrop for the grassy triangle situated between Grand Avenue and the forks of Waverly Place. The wooden fence rails provided a suitable resting place to gaze over Rainbow Park, as it was first named, toward the cove of Dering Harbor.

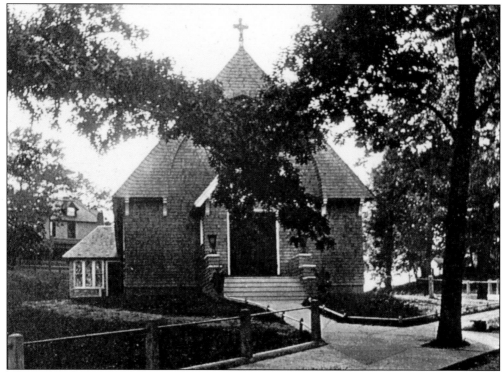

Our Lady of the Isle, *c.* 1945. The first mass held in the new Catholic church building was in the summer of 1907, ending the weekly trips to Greenport for many parishioners. The Manhanset House chapel had been used on occasion during the summer months.

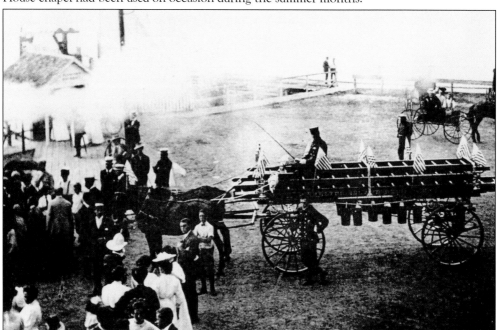

A horse-drawn, bucket-and-ladder wagon, *c.* 1895. Before a fire department was formed on Shelter Island, the town was dependent upon the Greenport Fire Department for equipment.

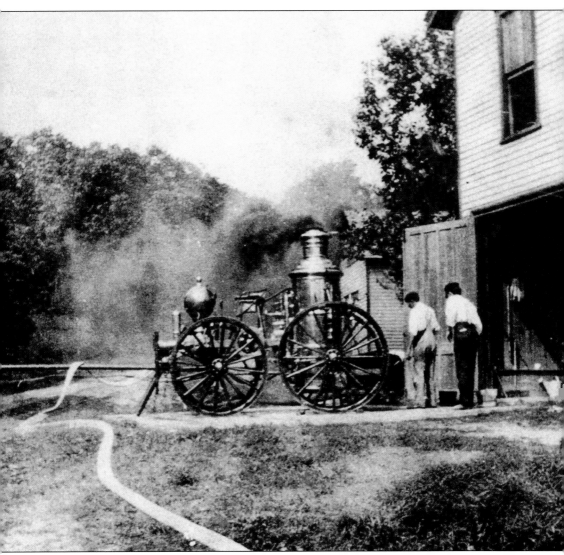

The horse-drawn steamer, c. 1915. Following a series of destructive fires in the early 1890s, a fire department was organized consisting of members of the Shelter Island Cornet Band. Frederick Schroeder, president of the Heights Association, suggested that the band, which was at the height of its glory in 1895, use the breath required to blow their horns for the purpose of dashing to fires. A loud bell in the firehouse tower alerted the volunteers. Since 1932, two fire departments have answered alarms with dedicated, well-trained fire fighters and rescue teams.

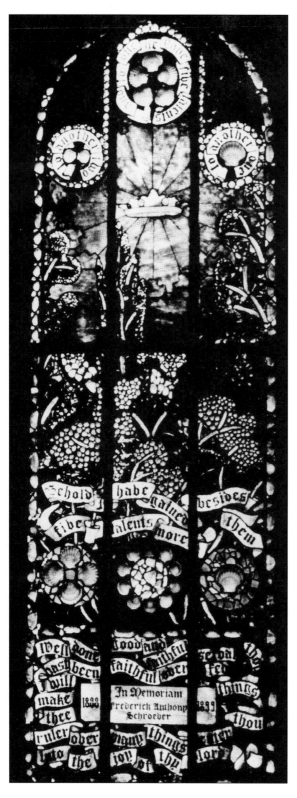

A Brigham memorial window made between 1902 and 1906. Walter Cole Brigham invented the technique termed "marine mosaic" using seashells, beach glass, translucent stones, and thick chunks of broken glass in combination with stained glass. He created beautiful windows, lamp shades, fire screens, and jewelry, mainly in the art nouveau style. Examples of his unique craftsmanship may be seen at Union Chapel.

Walter Cole Brigham (1870–1941). The young painter and stained-glass artisan established his studio on Shelter Island in 1899, following a year of study in Italy. In 1911, he married Jeannette Lawson, whose father managed the grand Manhanset House.

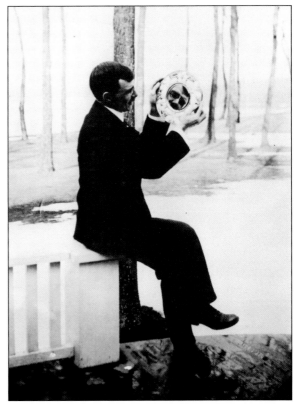

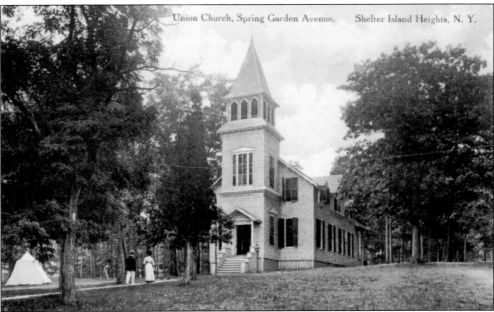

The Union Chapel in the Grove, c. 1900. By 1875, a simple wood-framed chapel had been constructed in the center of the camp meeting grounds where a preacher's stand and wooden benches had previously stood in the open air. Over eighty trees were lost in the grove during the 1938 hurricane.

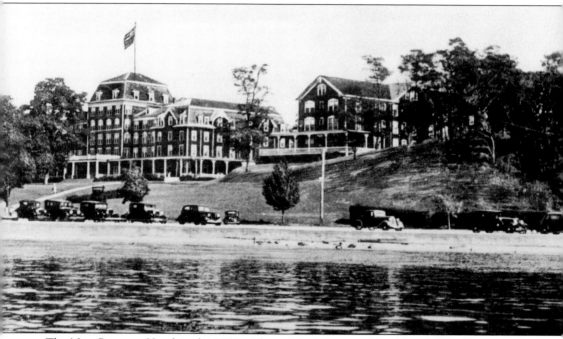

The New Prospect Hotel in the 1930s. The original Prospect Hotel opened its doors to guests in the summer of 1872. Improvements and innovations were added annually. A brochure from 1896 reads, "The building comfortably accommodates three hundred guests. During the winter fifty new rooms have been added to the hotel, duplicated electric plant and an improved hydraulic elevator reaching all floors, with the new furnishings, making the finest first-class family run hotel in the country. Rooms with bath and a new music hall. It is supplied with electric bells and the Edison light system in all its sleeping rooms and parlors, halls, dining-room, and on the piazzas. The dining room, enlarged, will seat the total number of guests at one time." Sometime after 1916, the Prospect Hotel became the Pogatticut. The hotel was badly damaged by fire in August, 1923. Repairs were made by the following season, and the New Prospect Hotel was open for business. It was ravaged again by fire in the early morning of June 26, 1942, and was never rebuilt.

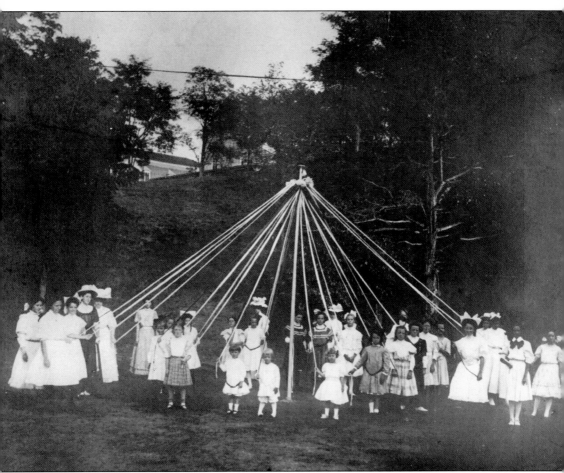

The maypole, c. 1903. The Shelter Island Grove and Camp Meeting Association's focus was on creating a family atmosphere which promoted spirituality and bodily health. Camp meetings and revivals fulfilled the first goal. Health was sought through swimming, boating, tennis, golf, and croquet. Well-kept parks and paths encouraged walking. The Entertainment Hall contained a dance floor, bowling alley, and billiard tables. An annual harvest festival was the social event of early autumn.

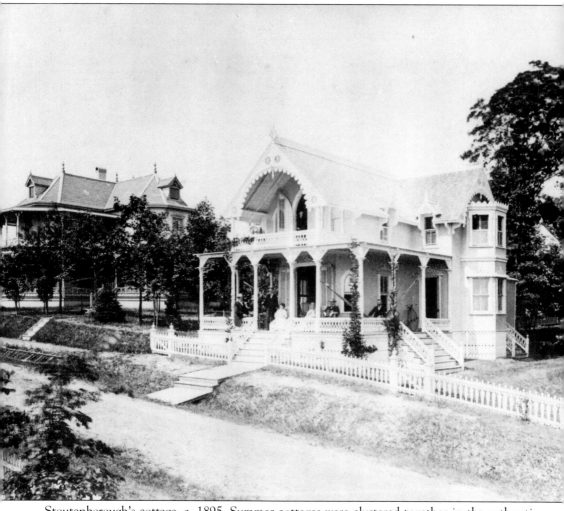

Stoutenborough's cottage, c. 1895. Summer cottages were clustered together in the authentic camp meeting fashion of the late nineteenth century. They had neither heat nor insulation. The earliest private cottages were without kitchens in expectation of communal meals at "The Restaurant." Bicycles first appeared on the island about 1893. Notice the bicycle on the porch of the Spring Garden Avenue home.

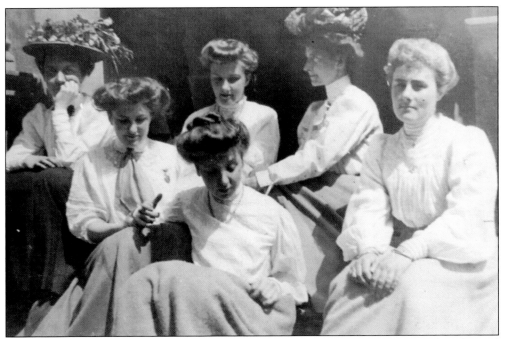

Fashionable ladies, c. 1910. Women dressed in finery for church meetings, travel, and social visits. The high-collared blouses and long skirts were typical of the era.

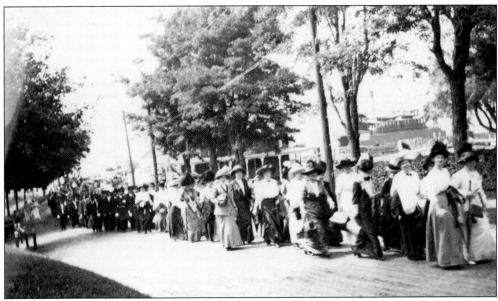

Prospect House guests, c. 1890. Steamships carrying up to three hundred passengers arrived at Prospect Dock from New York City. Hotel guests walked the short distance uphill to the lovely Prospect House.

A view from the Observatory, *c.* 1890. A wood-framed lookout tower was erected on top of White Hill as early as 1873 by Captain Osborn, who was accustomed to gazing off to the distant horizon from the helm of his sailing ship. From the observatory's vantage point, the waters surrounding Shelter Island were easily viewed. On a clear day, Long Island Sound and the Connecticut shore were visible.

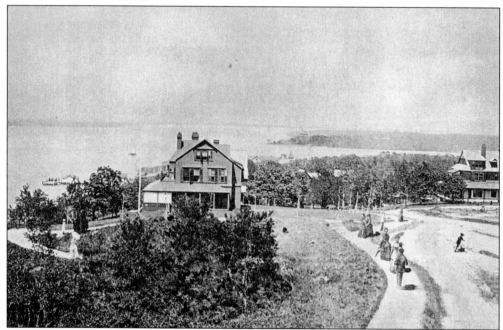

The Prospect Park area, *c.* 1890. The camp meeting colony was designed with residences, parks, a chapel, hotel, and restaurant. The first seventy cottages were built in the gingerbread-trimmed, folk style found in similar communities throughout America. Later houses reflected Queen Anne, Stick, and Colonial-architecture. Shelter Island Heights is listed on the National Register of Historic Places.

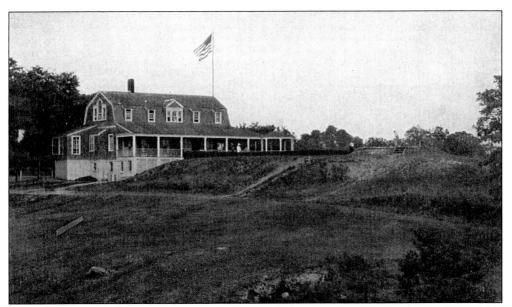

Shelter Island Country Club, *c.* 1910. The nine-hole golf course, laid out at the southern end of the camp meeting grounds, was known locally as the Goat Hill Golf Links. The clubhouse has been a center of activity since 1910.

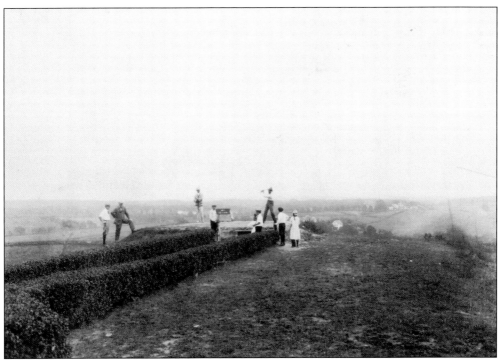

The first tee, *c.* 1905. The high rolling hills of the Goat Hill course have tested the endurance of golfers for over ninety years.

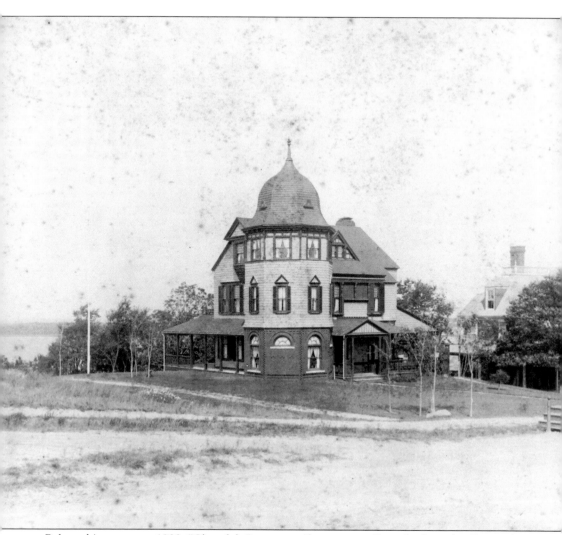

Behrends' cottage, c. 1900. "Chetolah," meaning "here we rest," was built in the Queen Anne style during the winter of 1883–84 for Frederick Behrends, a Doctor of Divinity. Several of Brooklyn's prominent ministers, who were part of America's religious revival near the close of the nineteenth century, built cottages along the bluff leading to White Hill. The area became known as Divinity Hill.

Schroeder's cottage, c. 1900. The Schroeder family's summer home was built in 1871. The Honorable Frederick Schroeder was a prominent figure in the Shelter Island Heights Association, holding the positions of president and treasurer. With the assistance of Heights Superintendent C. Wesley Smith, Schroeder sought to maintain the property in beautiful park-like condition. Frances, Harriet, and Adelaide Schroeder were photographed on the shaded porch with their parents.

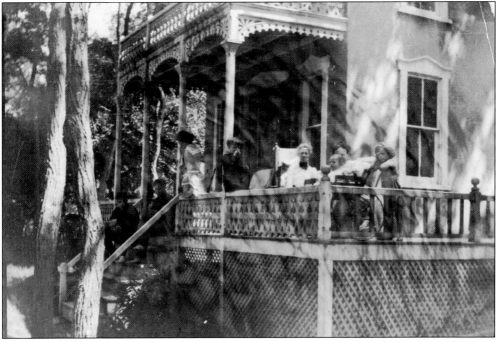

The Eggleston cottage porch, c. 1895. The charming home of the A.C. Eggleston family is pictured during the early days of the summer colony, when property taxes on a lot averaged $9.

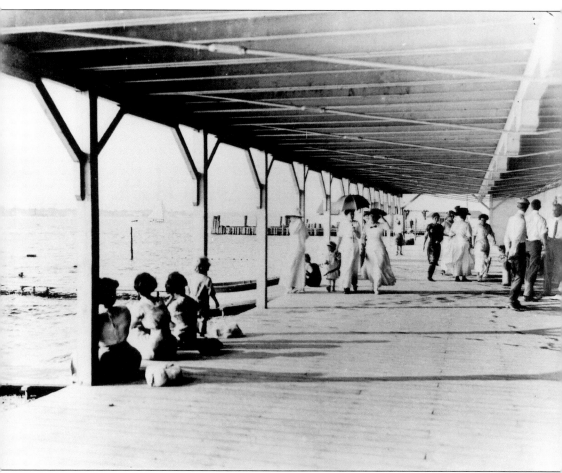

Prospect's bathing pavilion, c. 1895. The Prospect House boasted 250 bath houses filled to capacity in 1889. The broad veranda was a fashionable spot to watch the activities along the shore. A float equipped with two diving boards was crowded with wool-clad swimmers. In the evenings, guests paddled canoes and rowboats through the peaceful, moonlit water. During the 1920s and 1930s, three movies a week were shown on a wide screen, which was located on the float.

Four

Along the Shore

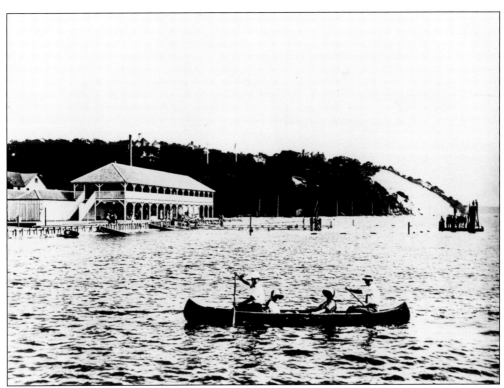

Canoeing near the shore, *c.* 1905. The bathing pavilion and White Hill provided a scenic view for paddlers.

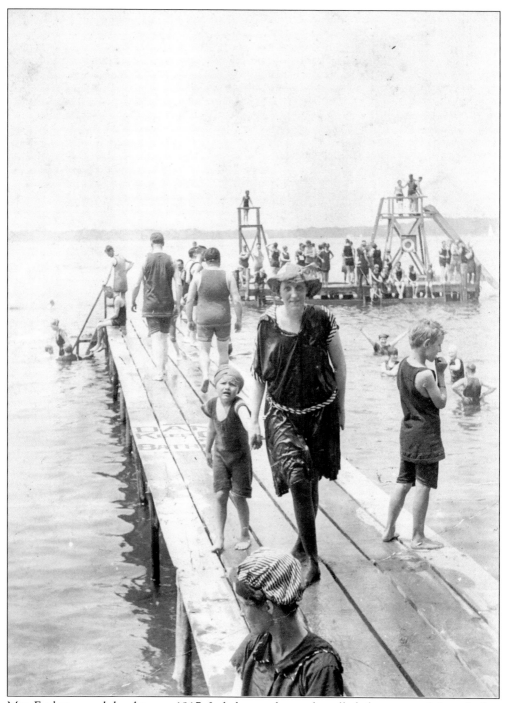

Mrs. Eggleston and daughter, c. 1917. Isabel was reluctantly pulled along toward shore by her mother, who wore the fashionable head-to-toe bathing attire of the day. Bathing suits were kept in the individually assigned bathhouses.

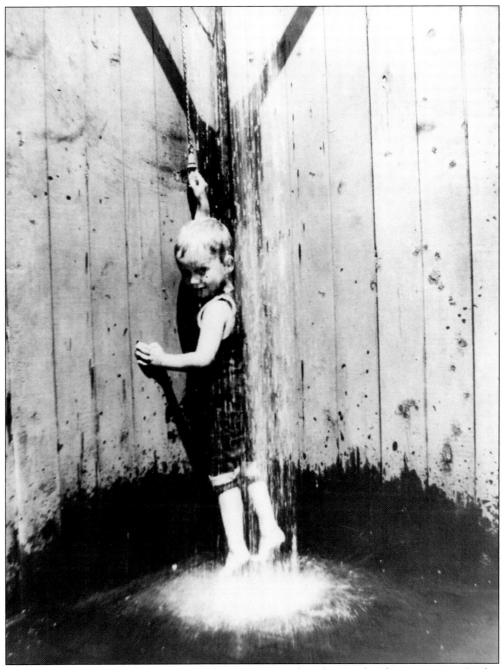

Royce Wight in July 1916. The Wight family summered in the Heights for many years. In this image, a young Royce pulls the chain for a shower at the Beach Club.

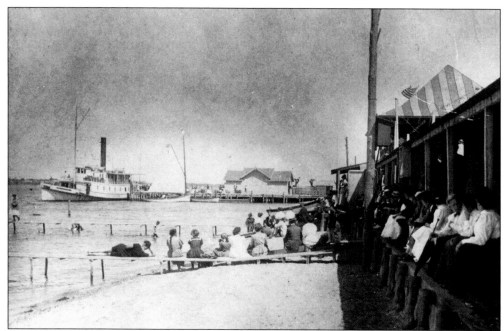

Prospect Dock, c. 1890. The bustling activity at Prospect Dock could be leisurely observed and discussed from the veranda of the bathing pavilion. In 1852, the ferry landing was moved from Stern's Point to a wharf at Bridge Street. About 1872, Prospect Dock was built for the ferry landing in summer. It became the year-round location for the North Ferry in the 1900s.

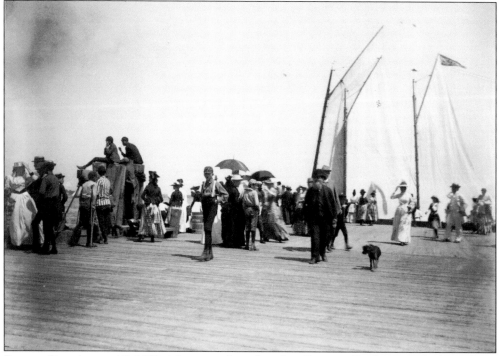

Regatta Day, August 17, 1889. Many people gathered at Prospect Dock to watch the sailboat races on Saturday and Sunday afternoons.

The *Cambria*, July 25, 1889. Frederick Chase Beebe owned and operated the ferry *Cambria* for over twenty years. He had converted the wooden fishing boat into an efficient steam-powered vessel. In the 1870s, train service was excellent, making the trip between Flatbush Avenue and Greenport in two hours. The *Cambria* was the first ferry to make use of the triangular route joining the Greenport Railroad Dock, Prospect Dock, and the Manhanset House Dock in 1883. The crossing cost 10¢ per person and 50¢ per horse, mule, or pleasure carriage.

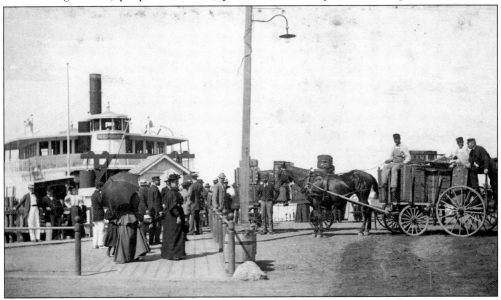

The *Menantic*, built in 1893. The double-ended steam ferry with two decks and a crew of four was a smaller version of the New York City ferries. Its width allowed three teams of horses to be carried on either side of the central cabin.

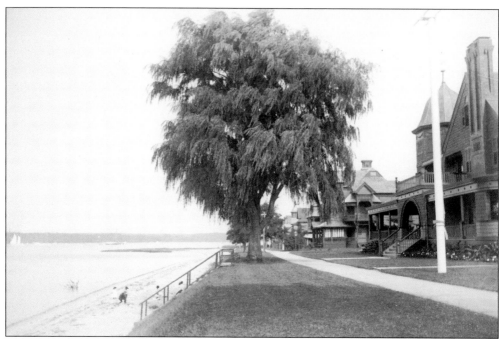

Willow Walk in 1889. Three of the first cottages built in the Heights are along Willow Walk. They are easily identified by the hexagonal kitchen annexes constructed after communal dining was abandoned.

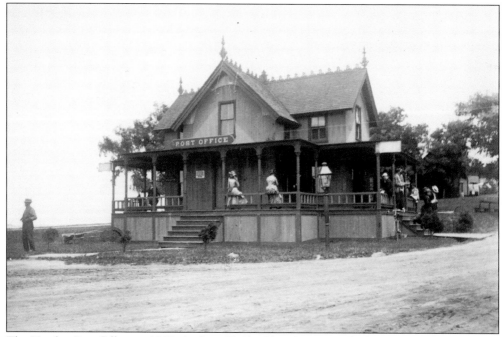

The Heights Post Office, c. 1889. Andrew K. Shiebler's home was built in 1875 on the site now occupied by tennis courts on Clinton Avenue. The house was moved to its present location near the ferry landing in 1884, where it was occupied by the office of the Heights Post Office, and later, the Shelter Island Heights Association.

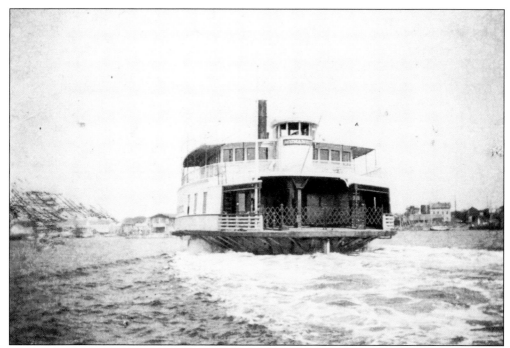

The *Menantic*, c. 1890. Steamboat whistles could be heard every five to ten minutes during the summer months, when the bays and harbors were filled with boats. The long wail of the train whistle also floated across the water, signaling the arrival of passengers aboard the Long Island Railroad.

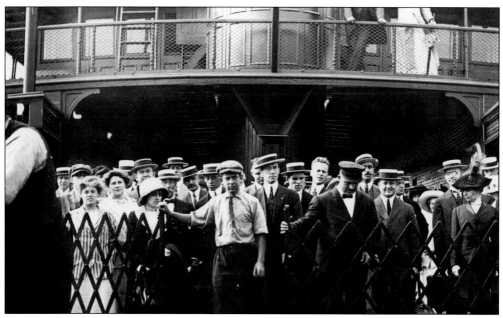

"Daddy's Ferry," c. 1912. On Friday evenings, the ferry boat was crowded with men arriving from a long work-week in Manhattan or Brooklyn. Eager wives and children awaited the arrival of "Daddy's Ferry" at the North Ferry terminal.

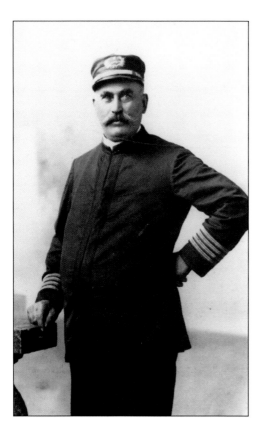

Captain Abram Mitchell, 1895. Capt. Mitchell piloted the *Shinnecock*, one of the great steam-powered paddle-wheelers that churned the waters from New York City to Eastern Long Island for the Montauk Steamship Company. Captain George Gibbs also commanded the helm of the *Shinnecock*.

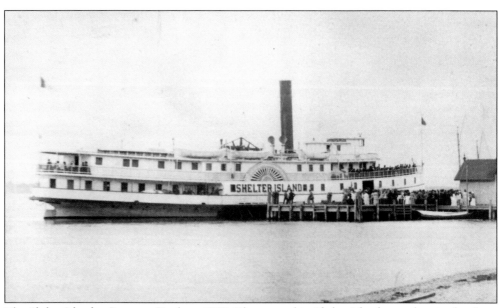

The *Shelter Island* at Prospect Dock, c. 1890. The steamship *Shelter Island* was advertised as "one of the new and elegant steamers of the Montauk company." The side-wheeler was equipped with gas-lighted chandeliers, which shone through long rows of windows, reflecting on the water at night.

Aboard the *Menantic, c.* 1900. Lillian Fisher posed with Agnes and Belle Clark on the upper deck of the *Menantic*.

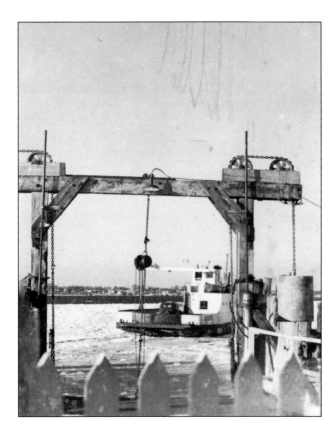

Ferrying through the ice in the 1940s. When the bays were packed with ice flows, the going was slow and very difficult. The ferries were often forced to suspend service.

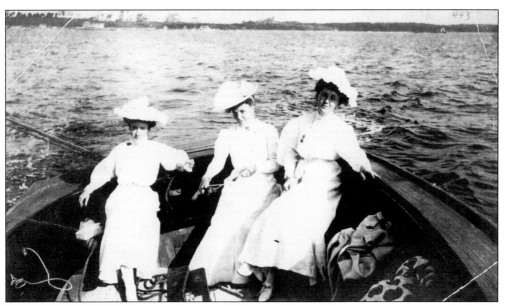

Daisy Price, Adelaide Schroeder Ames, and an unidentified sailing partner, c. 1910.

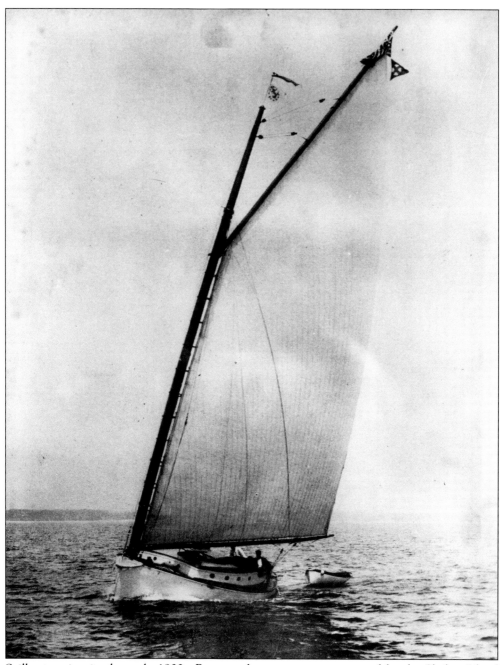

Sailboat racing in the early 1900s. Races and regattas were sponsored by the Shelter Island Yacht Club and, beginning in 1931, the Menantic Yacht Club. The catboat above was on a routine sail.

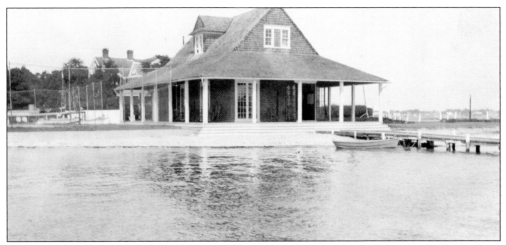

Shelter Island Yacht Club, c. 1905. Situated in one of the most protected and beautiful harbors on the North Atlantic coast, the Shelter Island Yacht Club was formed in August 1886. The officers quickly organized the club's first regatta, which provided for six classes of sailboats. By 1892, a clubhouse built by Thomas Burns stood on Chequit Point.

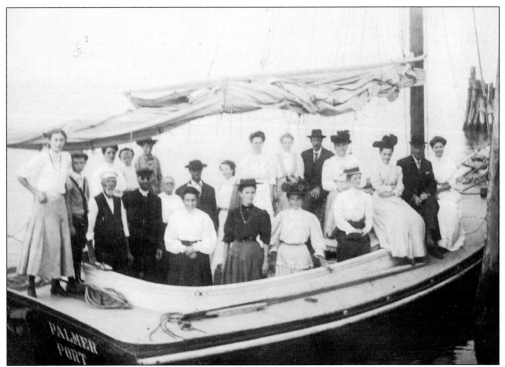

Sailing in 1908. Clear skies and a stiff breeze were reason enough to engage in sailing, a favorite island pastime. This group, however, was aboard for a photograph.

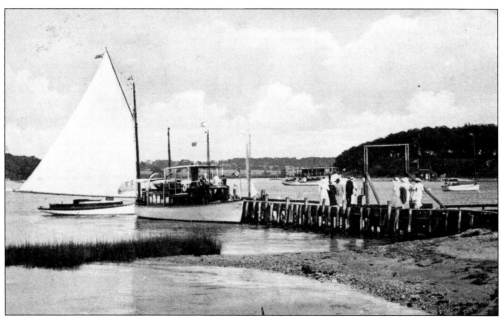

A dockside send-off at the turn of the century. At sunrise and sunset, guns were fired in a yacht club salute, which echoed across the water.

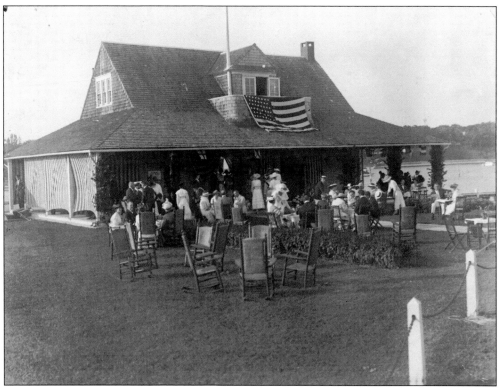

A yacht club party, c. 1910. Yachting has always been the emphasis of the club, but parties and social events are enjoyed as well.

Captain Russell Conklin, *c.* 1945. Capt. Conklin ran a successful boat leasing business at his wide dock, which jutted into Dering Harbor from its western shore. He leased rowboats, sailboats, and canoes, and he also took boating parties in his launch.

After crabbing at Conklin's Dock, *c.* 1928. From left to right are: Doug Dwyer, Jack Rome, Dee Hutchinson (the taller figure), James "Junior" Dwyer, William "Red" O'Conor, Captain Conklin (in the background), John "Windy" Windels, and G. Morris "Doc" Piersol.

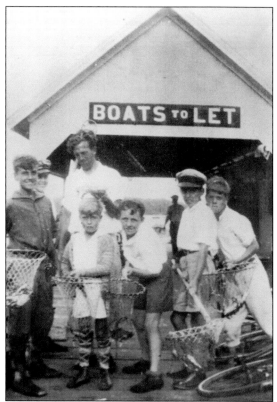

"Boats to Let," *c.* 1928. This is a photograph of Russell Conklin's boat rental dock.

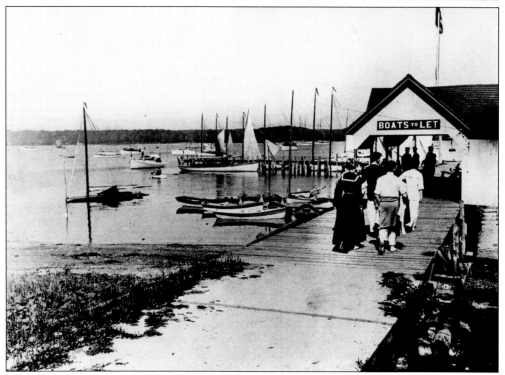

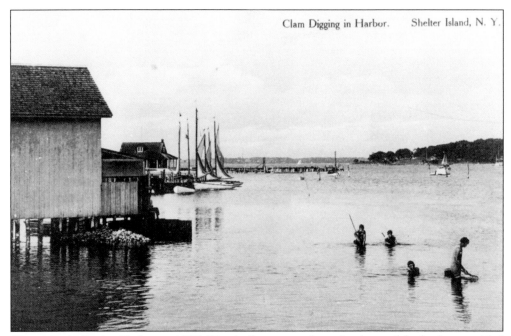

Clamming in Dering Harbor, *c.* 1905. The shallow water along the shore of the harbor provided a choice spot for clammers.

A drive along Cedar Avenue, *c.* 1900. Conklin's Dock and the boats in Dering Harbor may have caught the eye of a passenger traveling by horse-drawn carriage along the shorefront.

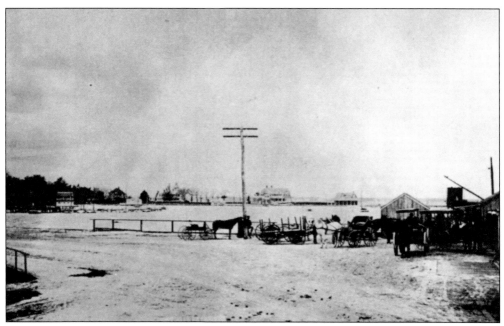

Middle Landing, c. 1895. The ferries and steamboats docked during the winter months at the eastern end of Bridge Street near Wilcox's Coal Dock. A grocery store owned by Squire Chase's son-in-law, Joseph Skillman, stood near the landing.

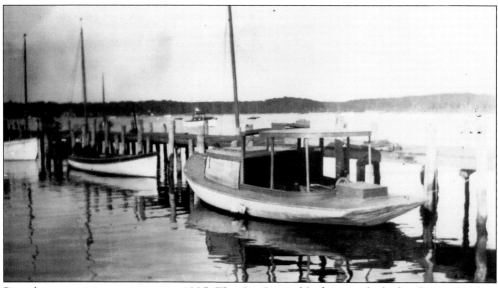

Party boats awaiting passengers, c. 1925. The *Cy*, *By*, and *Lydia* were docked in Dering Harbor.

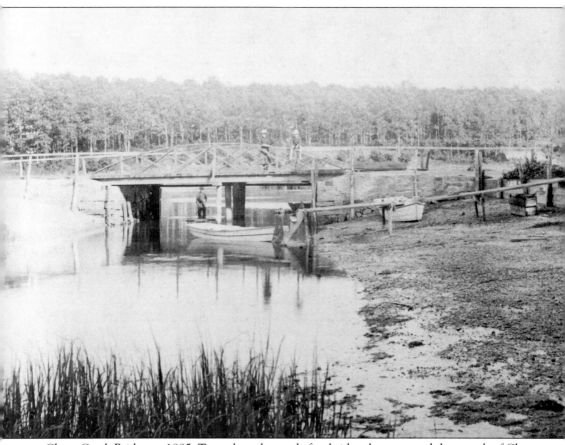

Chase Creek Bridge, c. 1885. To replace the crude footbridge that spanned the mouth of Chase Creek, the following resolution was passed on April 6, 1869, "That the Supervisor be authorized to build a bridge across Chase's Creek at an expense not exceeding one hundred dollars, provided he can obtain a right of way in exchange therefore to the usual landing place at the old dock, and the town raise one hundred dollars to pay for the cost of the bridge."

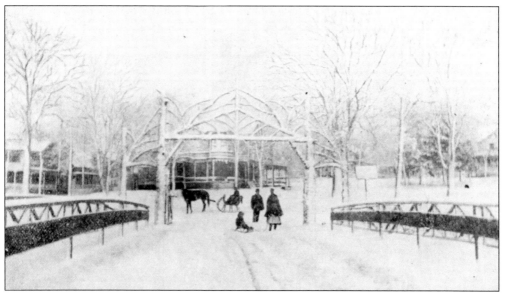

Chase Creek Bridge in winter, c. 1895. There were two entrances to the Heights, both marked by rustic wooden arches. One was at Second Bridge which crossed Chase Creek, and the other curved over New York Avenue at Ketcham's Corner. Once a year the gates were closed to allow the Heights to declare its roads as private.

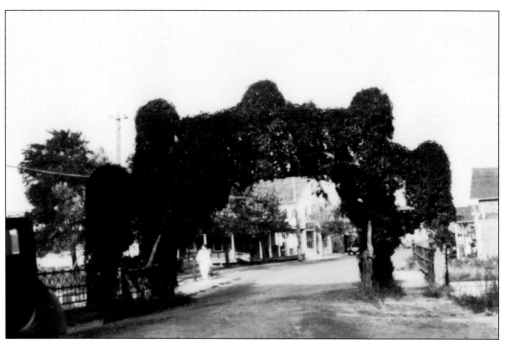

Bridge Street, c. 1900. A view past the woodbine-covered archway to the rapidly growing business area.

Thomas T. Young in 1896. Tom Young spent a happy childhood on Shelter Island occupying himself with the activities that boys enjoyed in those days, such as fishing, crabbing, trapping muskrat and skunk, ice-boating, and eeling through holes cut in the ice. In high school, he was the captain of the baseball team. As an adult, he was superintendent of the Shelter Island Light and Power Company for thirty-seven years. He had a keen interest in local history and was an active member of the Shelter Island Historical Society.

Five

School Days

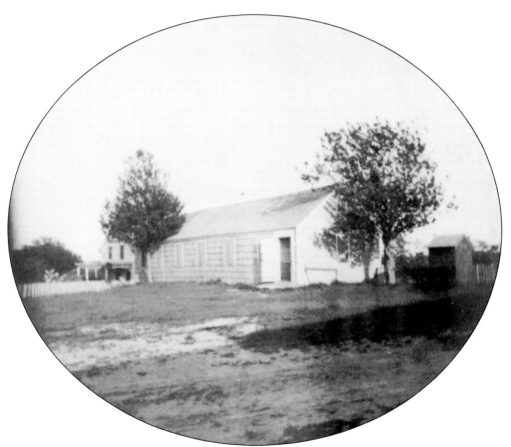

The Old Schoolhouse, built about 1830. The small, one-story schoolhouse was not the first building in which classes were held; the first schoolhouse had burned down by 1828. Stephen Burroughs had been hired as the first school teacher in 1771. His salary was $6 a month, plus board at James Havens' house.

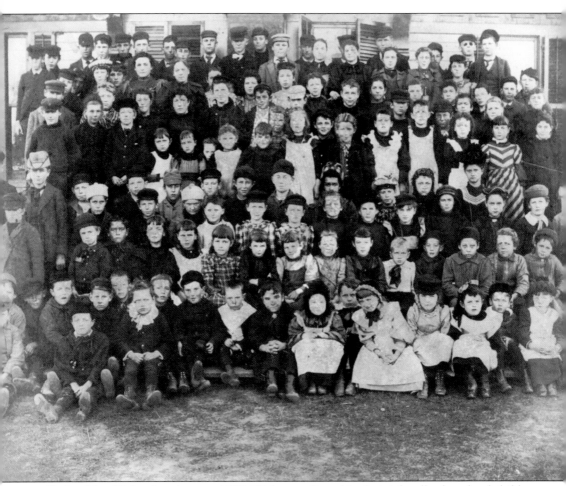

Shelter Island School students, *c.* 1890. With pens dipped in their inkwells, the school children spent hours perfecting their penmanship by imitating the rounded, beautifully scripted letters which formed moral messages in their "copy books." Older children wrote mathematical problems on their slates with chalk. Memorization played an important role in education. Poems, musical scales, and times tables were repeated often.

Cora Lee Jennings in 1904. Four-year-old Cora would begin her schooling when the time came for her to enter the first grade. Kindergarten classes had not yet been instituted at this time. At recess, she would be able to join her classmates in playing marbles, jack stones, and Red Rover. Miss Jennings had a natural talent for music, becoming the first female member of the Shelter Island Town Band.

Shelter Island School, built in 1868. The spacious "new schoolhouse," with three classrooms upstairs and three classrooms downstairs, was enlarged in 1880. A bell in the tower summoned the children to school where, upon their arrival, the older boys chopped wood and prepared the fireplace. They would then run to a nearby house for a firebrand to light the fire. Two young ladies were appointed to sweep the schoolhouse. The lower window panes were painted to discourage the pupils from gazing outside and daydreaming.

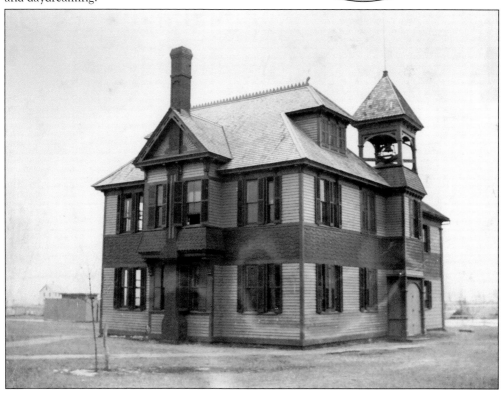

Miss Dodge, 1908. The school children looked up to their teachers. Young girls imitated their hairstyles and dreamed of the days when they would wear fashionable dresses like Miss Dodge wore. Many female teachers were brought to the island over the years to teach the youth. More than a few teachers found life to be happy and rewarding in the small community and married into local families.

J. Floyd Hallock and Leslie Littlefield, c. 1890. The school year was divided into four terms, with a vacation of three weeks in summer and only two holidays: Thanksgiving and Christmas. Classes were held from nine o'clock in the morning until four o'clock in the afternoon.

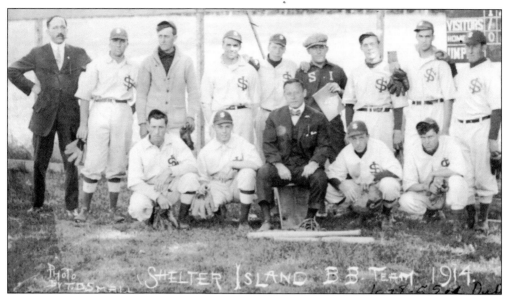

Shelter Island Baseball Team, 1914. Many young men continued to play baseball on the town team when their school days had come to an end. Kneeling, from left to right, are: Bill MacDonald, Henry Case, Lawyer Webster, Ed Payne, and Dick Griffing; (standing) C. Wesley Smith, Ed Raynor, Ollie Wells, Jack Bowditch, Kenneth Worthington, James Roe (manager), Norman Savage, Leo Donahue, and Carl Conrad.

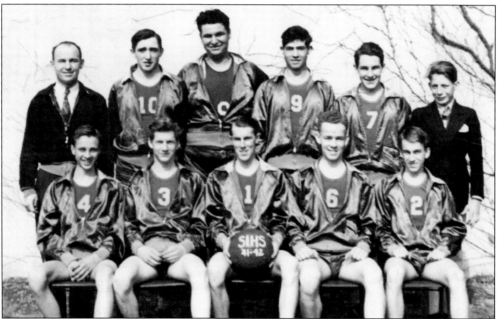

Shelter High School Basketball Team, 1941–42. Most of the players on the 1942 basketball team would soon be going off to fight in the war. From left to right are: (front row) Clarence Barker, George Dickerson, Gardner "Tink" Dickerson, Kenneth "Bud" Clark, and William Dickerson; (back row) Coach Koslik, Jack Reeves, Frank Silvani, Charles Avona, Kenneth "Bo" Payne, and George Worthington. Second Lieutenant Charles Avona lost his life while flying his plane over Germany in 1944.

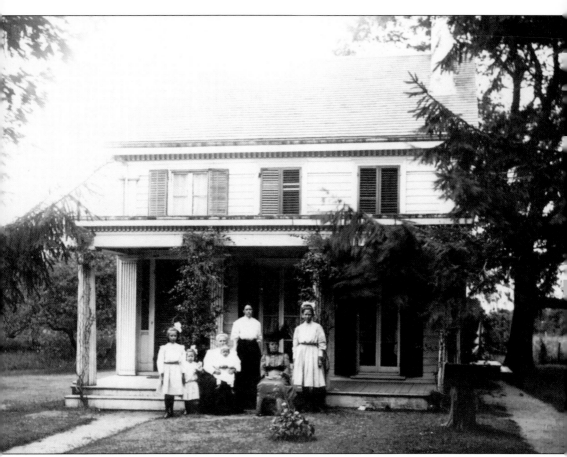

Captain Charles Harlow house, *c.* 1900. The Greek Revival-styled house on North Ferry Road was built by Gabriel Crook between 1820 and 1849, while whaling was at its height. Many houses of comparable architecture line the curving streets of Sag Harbor and are simply called "Captain's Houses." When gold was discovered in California, Gabriel Crook and twenty-four other island men went west with the forty-niners.

Six

Homesteads and Farms

The Harlow house at the turn of the century. Many families lived in the Captain Harlow house over the years. The home may be seen at its original site on the corner of Winthrop and North Ferry Roads.

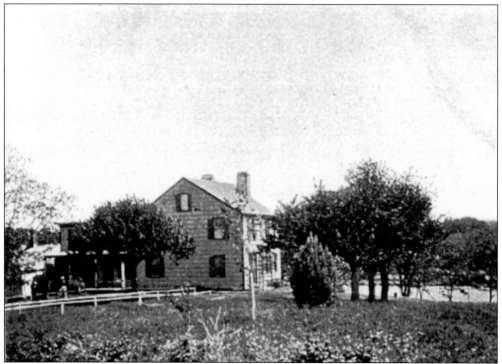

"The Homestead" in earlier days. The greatest part of the Conkling-Griffing-Duvall farmhouse was built in 1828, using Shadrach Conkling's kitchen which was so firmly jointed by wooden pegs that it resisted razing. The two-story wing was added in 1856.

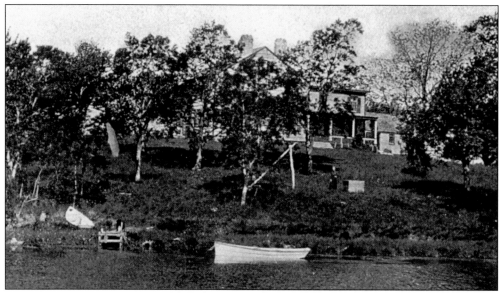

The farmhouse on Gardiner's Creek, c. 1910. Moses Griffing, who succeeded Frederick Chase as the town supervisor in 1824, built "The Homestead" after marrying Asenath Conkling. The original bark still clings to the mighty hand-hewn framing timbers. Five fireplaces and a Dutch oven served for heating and cooking for well over a century.

Ralph Griffing Duvall (1861–1941). Ralph Duvall knew Shelter Island's history well. He was instrumental in organizing the Shelter Island Historical Society in 1922, and he wrote numerous papers based on his extensive research of the island's past. In 1932, he published *The History of Shelter Island*. Mr. Duvall was born in "The Homestead" in 1861.

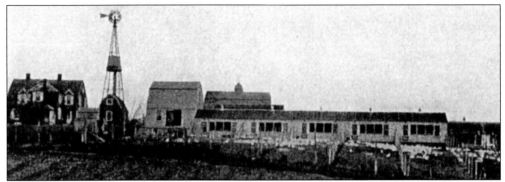

Thornehaven, *c.* 1910. The Charles E. Thorne house was built in 1889 by Charles Corwin. The home was originally called "The Crossroads." The Woods family eventually bought the property which is situated at the junction of West Neck and North Ferry Roads, known locally as Woods Corner. Thornehaven has recently been restored.

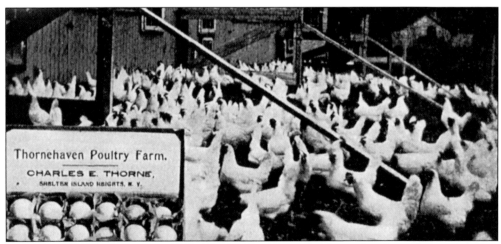

Thornehaven advertisement, *c.* 1910. Charles Thorne operated a poultry farm. Eggs and poultry were also raised at Cackle Hill and Ward's Farm. Milk was produced at Jennings Dairy, Sylvester Manor Farm, and Never Never Land Farms.

A calf christening, c. 1900. Farmers were thankful in the spring for the birth of livestock and for the new crops growing in their fields. It was cause for celebration, as was the fall harvest. Neighbors worked side by side at wearisome tasks and upon completion, usually joined in a joyful social gathering.

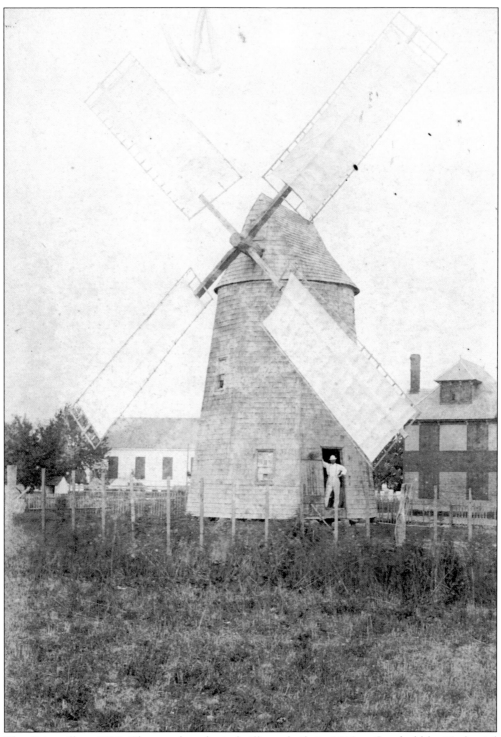

The Gristmill, *c.* 1890. The weathered windmill was built in 1810 at Southold by Nathaniel Dominy Jr., using parts of a previous mill. It was moved to Shelter Island by barge and put to use grinding corn and wheat at its location by the schoolhouse.

The Parsonage, built about 1800. The large farmhouse served as a parsonage for the Presbyterian minister, Charles Holloway, who filled the position left by the late Daniel M. Lord. The highly respected pastor died from the injuries received when he was suddenly thrown from his wagon. Captain Edgar P. Baldwin and his family last occupied the house which was destroyed by fire in the late 1920s.

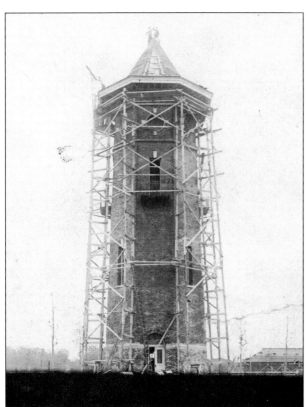

Turner's Tower, *c.* 1912 The distinctive red brick clock tower was built in 1909. "Mammoth" bells tolled the hour. During a production of *Peter Pan*, a wire was strung from the tower's peak to a nearby barn to stage the flying scenes in J.M. Barrie's much-loved play. Westmoreland took on the new name of "Never Never Land."

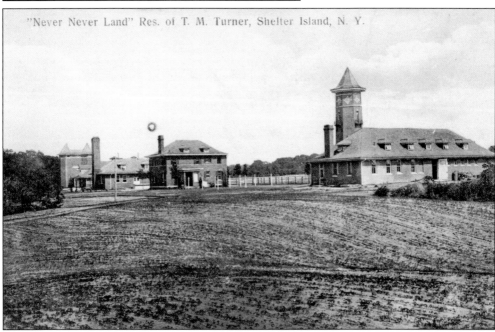

"Never Never Land" Res. of T. M. Turner, Shelter Island, N. Y.

Westmoreland Farm in 1901. Thomas M. Turner farmed the land which wraps around the southern confines of West Neck Bay. The handsome farm buildings were made of brick. A dairy supplied fresh quarts of milk for island families.

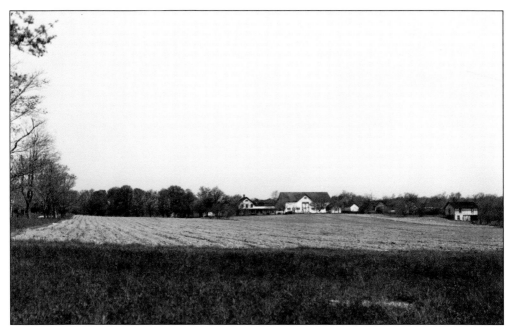

The Artemas Ward Farm, c. 1920. The 17-acre Ward Farm originally belonged to Caleb Loper and his son Marcellus D. Loper. Mr. Ward added facilities for raising horses, hogs, chickens, and pheasants. Since the fish factories were no longer producing fertilizer on Shelter Island, Artemas Ward had boatloads of manure, which had been shoveled from the streets of New York City, shipped to his stone loading dock near South Ferry.

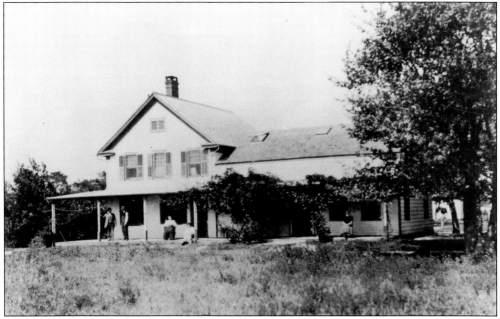

The Loper-Ward farmhouse, c. 1900. The cornerstone in the east wing attests to the fact that the low, long farmhouse on Osprey Road was built in 1803. Artemas Ward bought the property in 1892, expanding the landholding to 220 acres during the coming decade.

A manor house in Shorewood, *c.* 1915. Artemas Ward, the philanthropist, advertiser, and publisher, bought the land which he named "Shorewood" in 1892 from the Loper family. His manor house stands on the bluff of Ward's Point overlooking Peconic Bay and Shelter Island Sound. The large, rambling residence has picturesque balconies and a four-story lookout tower. To the east, a huge stone boathouse dominates the waterfront. The arched loading pier, made of concrete and stone, was 300 feet long. It is now crumbling into the sea, as is the concrete seawall and promenade that edged Ward's Point.

The Artemas Ward family, c. 1900. The Ward family posed on the lawn of their summer estate in Shorewood. Artemas Ward was born in New York City in 1848. He became a pioneer in the field of advertising, which rapidly moved forward with his imagination and expertise.

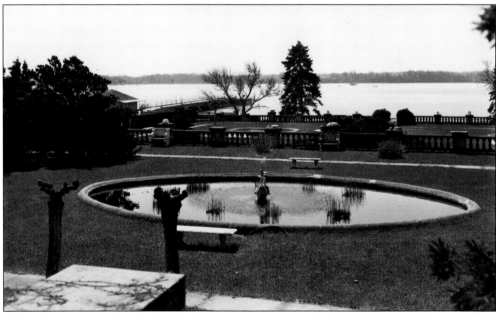

The formal gardens at the Ward manor, c. 1910. The sunken Italian gardens are enclosed with concrete, arch-paneled walls. Built by Italian workmen at the turn of the century, the gardens are decorated throughout with marble benches and statuary. Two marble lions guard the stairway. A sculptured swan fountain graces the central pool.

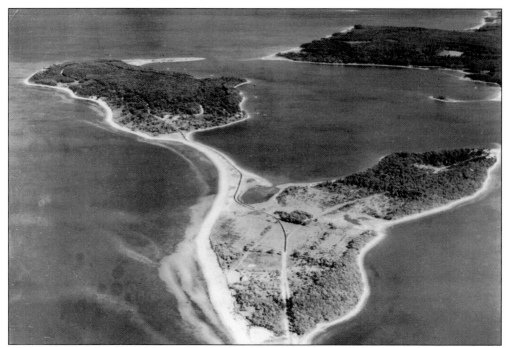

An aerial view of Ram Island, *c*. 1928. In the earlier days of Shelter Island's history, sheep were driven on to Ram Island each summer to graze. The islands were fenced off until cool weather arrived. The fattened animals were then driven back to their winter pastures. The open fields of salt hay and thick rolling woodland were encircled by seven miles of beautiful beaches.

The Tuthill homestead, *c*. 1915. In the 1770s, Daniel Tuthill built a gambrel-roofed house with two beehive ovens on Little Ram Island. Both Big and Little Ram were true islands at high tide in those days. It was a two-day trip by horse-drawn wagon along the dirt road leading from Turkem's Neck, across the rocky causeway beach, and up the long hill to the old homestead surrounded by apple orchards.

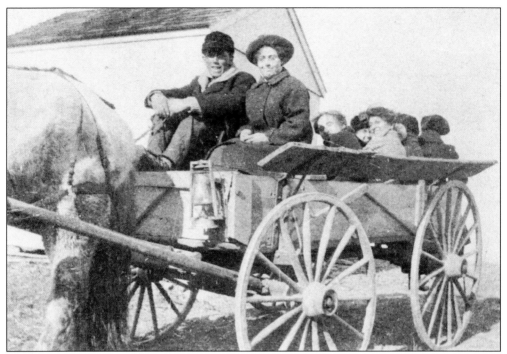

Everett and Olive Tuthill with friends, c. 1918. Fragrant cedar trees with thick, feathery branches dotted "First Causeway." It was there that Everett Tuthill and Elliot Dickerson cut the annual Christmas tree for the Presbyterian church. It is only in the last quarter century that the Ram Island cedars have become so proliferous that the view to the water is obscured.

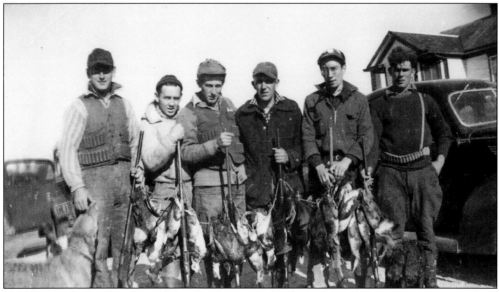

Ducking in the 1930s. One of the favorite spots for duck-shooting sixty years ago was from burlap-lined blinds along "Second Causeway." Pictured here after a cold morning spent hunting, from left to right, are: Ed Conrad, Bob Tybaert, Trio Johnston, Raymond Case, Alfred Tuthill, and Chick Dickens. Pheasants, rabbits, and deer also provided food for the table.

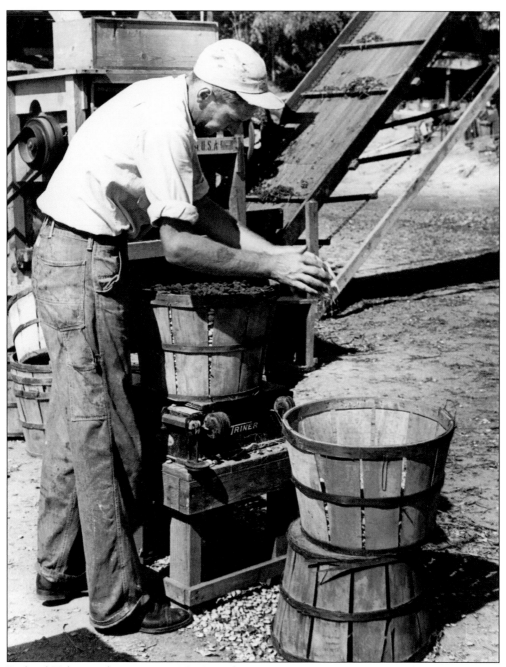

Richard Halsey at the viner, c. 1951. Lima beans were an important source of income, as were potatoes, cauliflower, and cabbage. The harvested crops were trucked to the auction block in Southold to be sold. In response to the uncertainty of prices, high harvest costs, and ferry tolls, a group of island farmers formed a cooperative to supply frozen beans to national food distributors. Members of the Shelter Island Farmers' Cooperative formed in 1949 were Anton Blados, Albert Dickerson, Elliott Dickerson, John Garr, Evans Griffing, Richard Moser, Frank Mysliborski, Sylvester Prime, and Everett Tuthill.

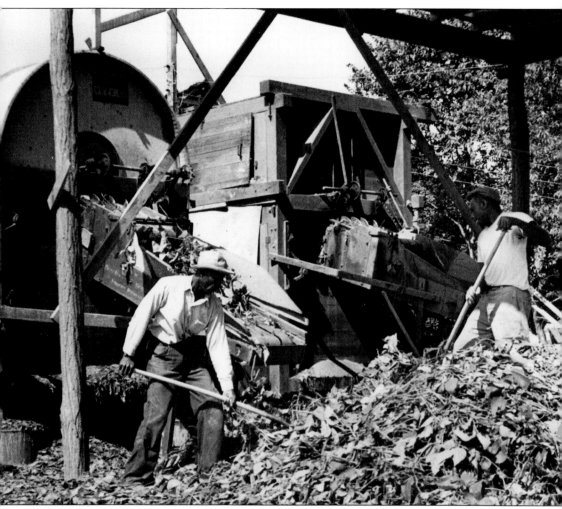

Pitching the vines, *c.* 1951. Migrant workers from the South, who were hired and provided with housing, pitched vines ripe with beans into the viner. The bean pods were knocked loose from the vines, opened, and shelled. Each co-op member farmed a 30-acre parcel for processing. The yield from additional acreage continued to be sold at auction.

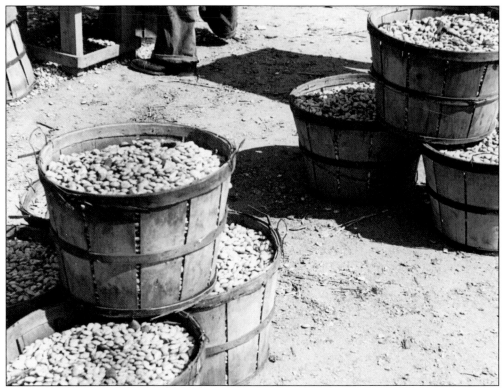

Bushels of lima beans, *c.* 1951. Baskets of lima beams awaited trucking to the processing plant on South Ferry Road, where the Town Highway Department eventually took up residency.

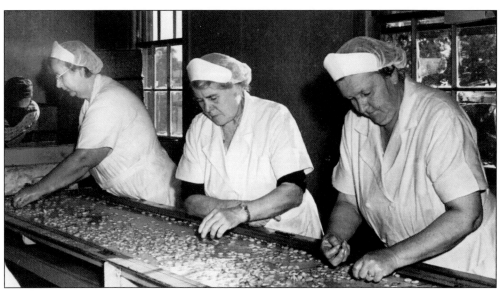

Working the bean grader, *c.* 1951. Mary (Sherman) Bourne (on the far left), Hilda Whitman (center), and Mary (Conrad) Hawkins (on the right) sorted lima beans on the moving belt of the grader. Large overripe beans, pieces of vine, and debris were culled out. The co-op employed more than sixty workers.

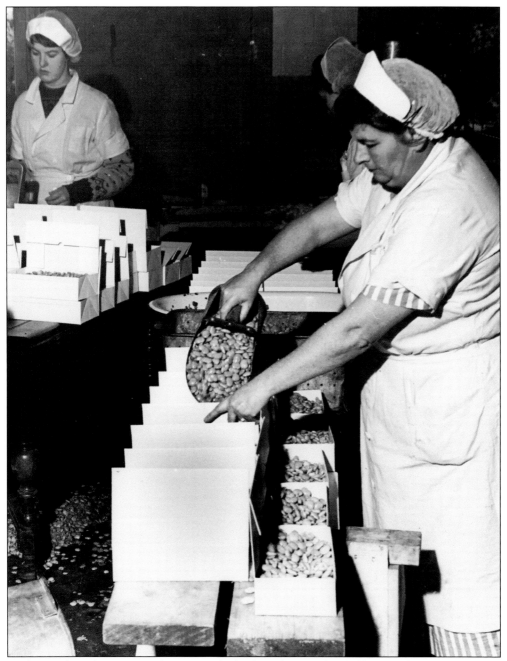

Packaging lima beans, c. 1951. Joan Schultz (standing at the far left) and Anna (Dickens) Congdon (foreground) boxed the washed and graded beans for flash freezing at the processing plant, which operated six days a week, twenty-four hours a day during harvest season. Farmers turned to the bays for their income during the winter months, using the plant to process and freeze oysters. The farmers' co-op disbanded after a blight wiped out the oyster beds along the north Atlantic Coast.

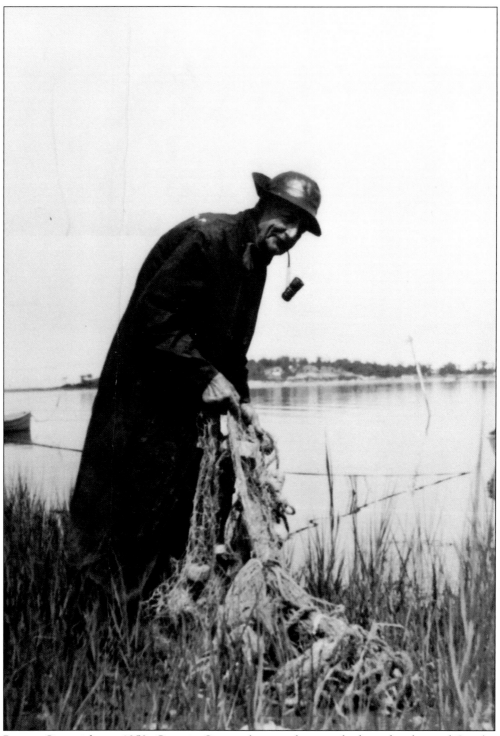

Roscoe Cartwright, *c.* 1952. Captain Cartwright was photographed on the shore of Coecles Harbor with Ram Island visible in the background. Baymen have an inherent knowledge of wind, weather, and tide. They are aware of the most productive fishing locales and conditions.

Seven

Island Waters

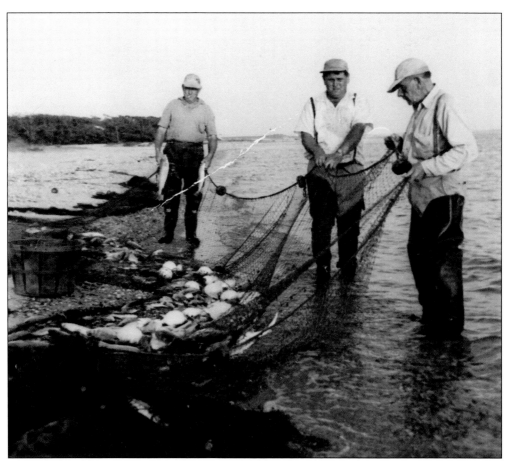

Hauling the seine, c. 1949. Carl Conrad, John Tuthill, and Dick Johnston reaped the rewards of their haul. After setting the net by rowboat, six or eight fisherman would man the lines. Hauling in a seine bulging with fish demanded teamwork in the steady hand-over-hand motion that kept the lead line low in the water and the corks afloat.

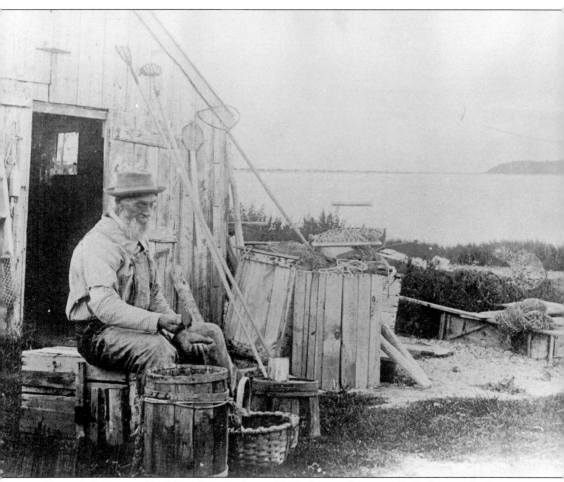

Captain Benjamin Conkling Cartwright, *c.* 1885. At age fourteen, B.C. Cartwright became a seafarer. He continued to work on the water all of his life. Upon returning from his last whaling voyage in the late 1840s, Captain Cartwright joined the local fishermen in establishing pot-works and steam factories for the processing of menhaden (moss bunkers) into oil, fertilizer, and phosphate. The menhaden fisheries became a leading island enterprise for nearly fifty years. Captain Cartwright served as the town supervisor and as an elder in the Presbyterian church for many years.

Bennett's fish camp, c. 1910. Every Sunday, from early winter through late spring, George Bennett walked with a load of supplies from his home at West Neck to his fishing shack on Ram Island. He returned home each Saturday. Capt. Bennett was one of many fishermen who joined in the fyke fishing business, which flourished from 1870 until 1924.

Tuthill's fish shack, c. 1920. Fyke fishing was accomplished by setting a hooped net, called a fyke, in the waters off-shore. Bottom fish swam into the funnel-like opening and through a series of graduated net covered hoops into the holding area of the fyke. The fish were then gathered and boxed for shipment to the Fulton Street Fish Market, by way of the Long Island Railroad. In the above photograph, a picnic was being enjoyed by the Nelson White family.

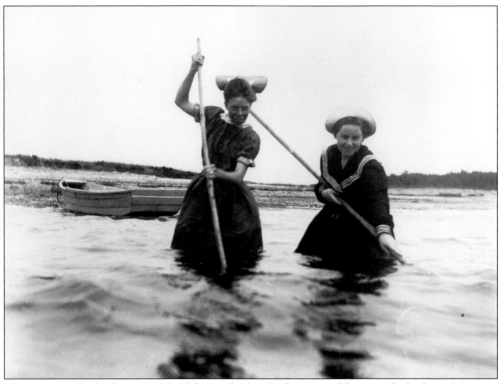

Clamming in the harbor, *c.* 1908. Helen and Alice Parker were able to reach the best clamming spots in Coecles Harbor by rowboat.

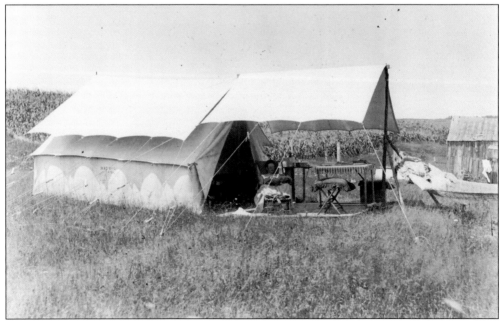

The Parkers' summer home, *c.* 1908. William Parker's first island home was a tent pitched amid the corn fields near the shore of Coecles Harbor.

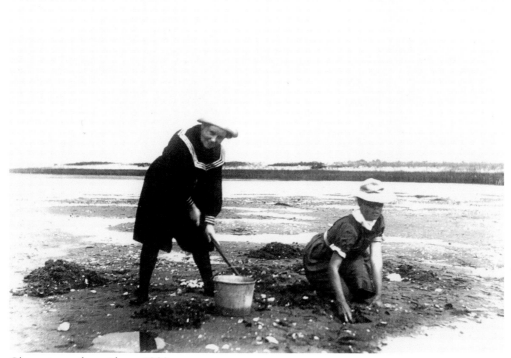

Clamming at low tide, *c.* 1908.

Coecles Harbor shoreline, *c.* 1910. Coecles Harbor Marina & Boatyard now operates along the waterfront at the foot of Hudson Avenue.

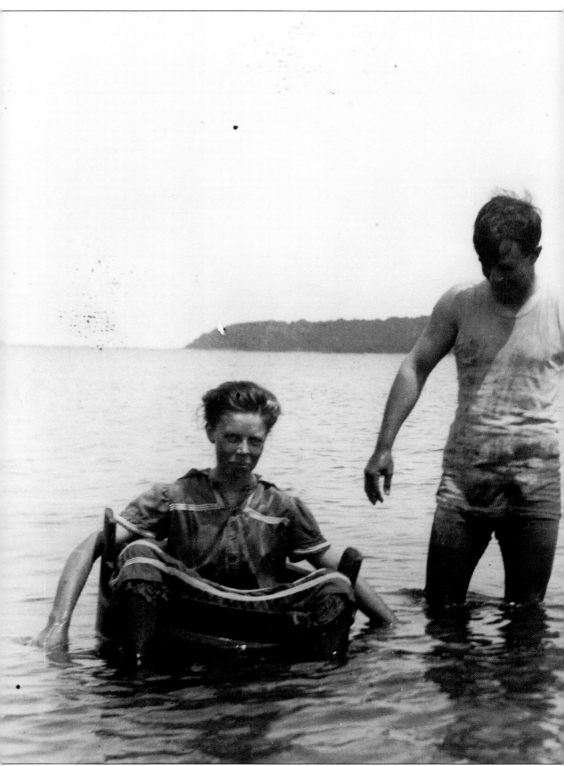

A Shelter Island summer, c. 1908. The Parkers and Barretts had "barrels of fun" in the refreshing

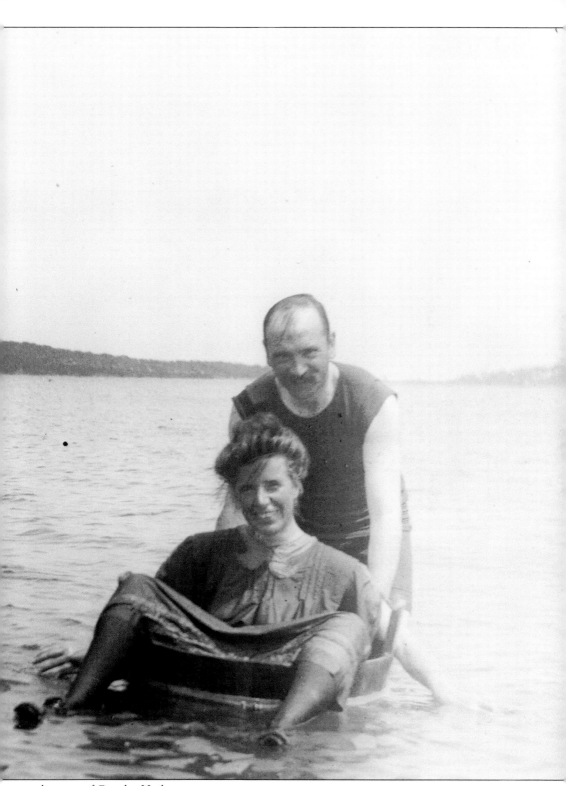

salt water of Coecles Harbor.

Alfred W. Tuthill on his workboat, c. 1949. Alfred W. Tuthill farmed in the spring and summer, but during the colder months, he turned to scalloping in his hand-built boat equipped with dredges and culling boards. Two net-drying reels are pictured on the sandy point leading into Menantic Creek. The scallop boat was docked in a small cove called "The Shrimp Basin," which contained an inlet for storing cars of freshly caught shrimp.

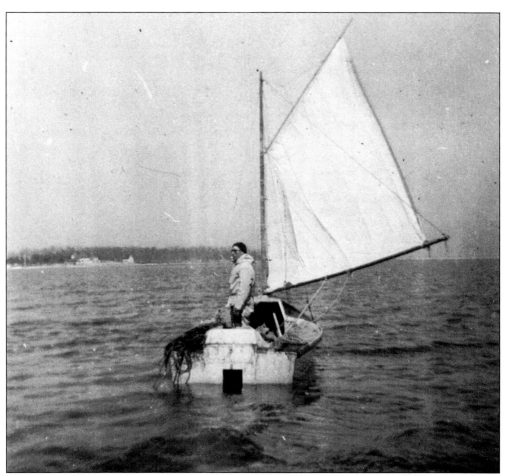

Alfred Tuthill sailing for scallops, c. 1949. A scalloper's day was spent throwing and hauling dredges. Warping by hand and sail power was used until the 1950s, when motor-powered scallop boats became common. Evenings were devoted to opening the catch and mending dredge nets. The freshly opened scallops were sold by the pound at wholesale scallop shops, like the one owned by Morris Tuttle on South Ferry Road.

A bushel of oysters, c. 1935. Frank Beckwith and Frank Turner carrying a basket of oysters near Hudson Avenue.

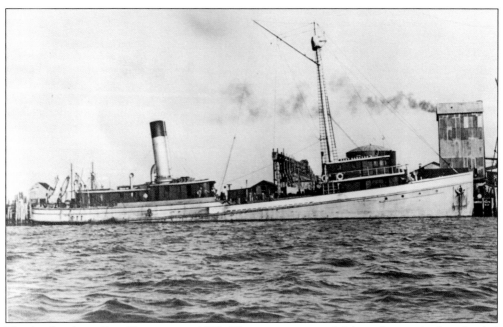

The bunker boat *East Hampton, c.* 1938. The steam-powered fishing boat, which unloaded its catch at the large fish factory at Promised Land near Amagansett, was piloted by Captain Kenneth Payne. Frank Turner was chief engineer, and Frank Beckwith was the oiler.

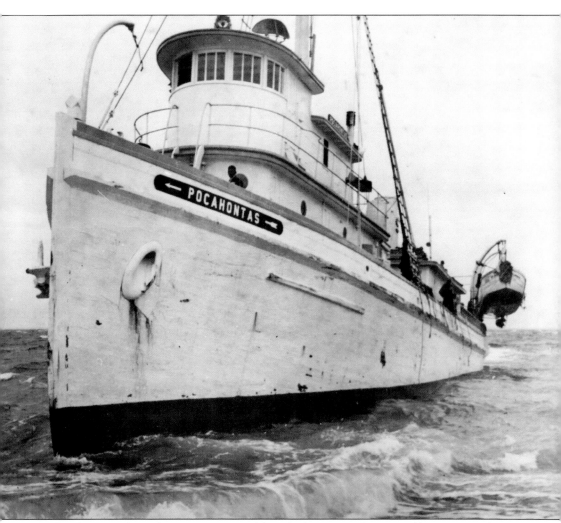

The diesel-powered *Pocahontas, c. 1940*. Although the pot-works at Scudder's Cove, Chequit Point, Dinah's Rock, and Bunker City on Ram Island had been shut down in the 1870s, many island men still worked on the bunker boats. The blossoming resort business had forced the factories to cease operation due to their unpleasant odor. The boat *Pocahontas* was built in 1912. Captain Kenneth Havens Payne was in command from 1946 until 1953. In 1953, his crewman and son, Kenneth "Bo" Payne Jr., became captain and continued fishing off Long Island through 1960, when the schools of menhaden moved farther south.

Capt. W. Otis Payne (1850–1915). Otis Payne was captain of the menhaden steamer *Ranger*, that made fishing trips of one and two days. His father, Elias Woodruff Payne, sailed a whaling ship for one to two years in search of whales.

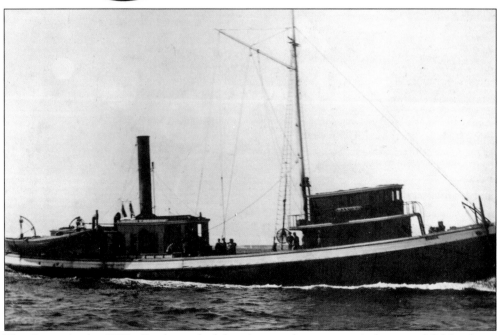

The *Ranger* in the 1930s. By the end of the nineteenth century, wind-powered fishing boats were, for the most part, abandoned or converted into steam-powered vessels. The crew of the *Ranger* fished for menhaden.

Eight

South Ferry Area

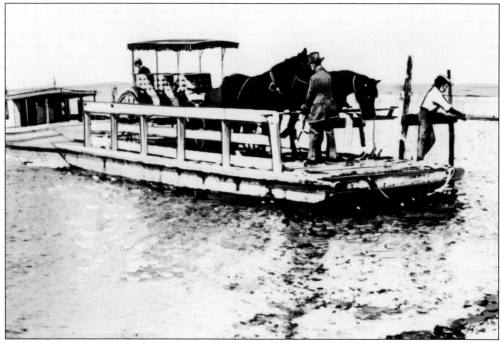

The *Reba* with scow, c. 1906. The catboats *Elloine* and *Fannie* used sail power to ferry passengers while pulling a scow with cargo and carriages across the channel. Horses were often tethered to the scow for the short swim. Within a few years, a larger scow was built which could carry a rig with harnessed horses. The *Reba* is pictured above, pushing the loaded scow.

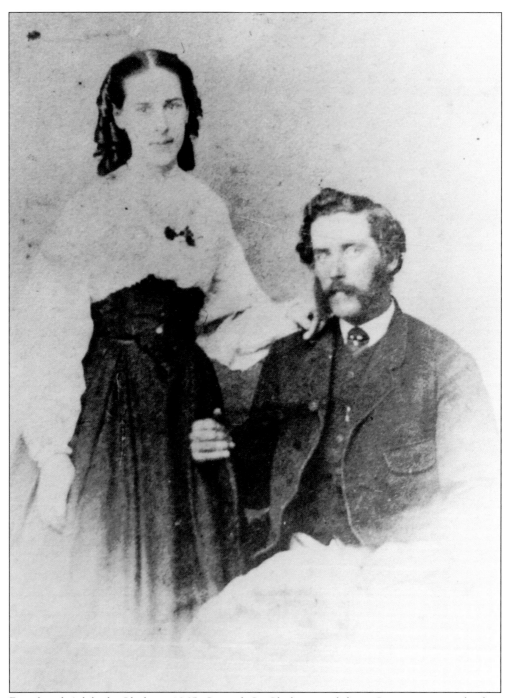

David and Adelaide Clark, c. 1865. Samuel G. Clark arrived from Connecticut in the late 1700s. He purchased farmland on the south side of the island and introduced a ferry service using a rowboat to shuttle travelers between Shelter Island and Hog Neck (North Haven). Samuel's son, David, expanded the service by adding the sail-powered *Elloine* and *Fannie*. He also continued to farm, while his brother, Samuel Jr., began a successful boarding house business at Clark's Cove.

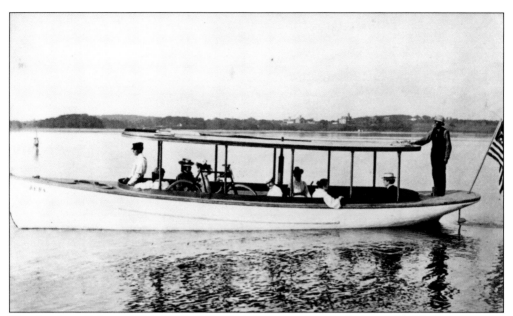

The ferryboat *Reba*, c. 1906. Clifford Y. Clark is pictured at the helm of the 26-foot passenger boat. His father, David Clark, stands on the stern. South Ferry Company was incorporated in 1906, the same year that the company launched the *Reba*. The ferryboat was the first gasoline-powered vessel on eastern Long Island.

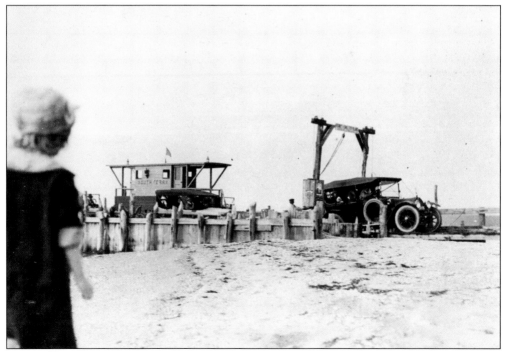

The *South Ferry* at North Haven, c. 1910. The double-ended *South Ferry* went into service in 1910. Two years later, the landing docks were moved from East Landing in Smith Cove to their present location at the terminus of South Ferry Road.

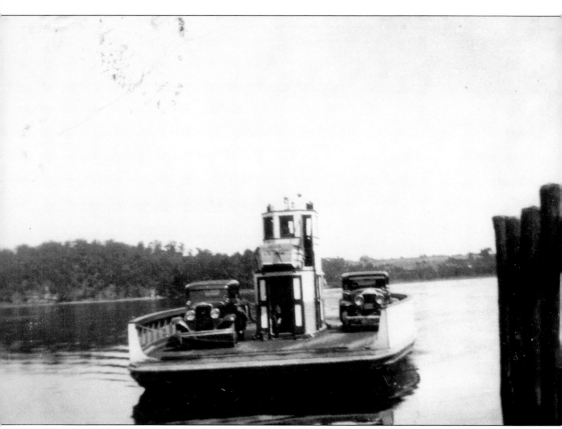

The *Southside* approaching East Landing in the 1930s. In 1923, Captain Clifford Y. Clark constructed the *Southside*, a 65-foot, double-ended wooden vessel. It was converted to diesel power in 1943.

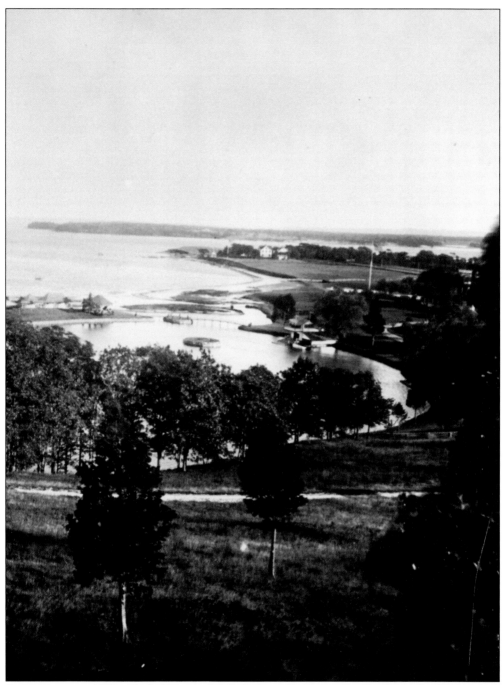

Smith Cove, c. 1900. Clark Cove gradually became known as Smith Cove after F.M. Smith bought 40 acres along its western shore. The property included the old Maltby Cartwright house. By 1900, the Smiths had added over 200 acres to their estate and built a concrete seawall to control the beach erosion caused by storms. The cove provided a protected anchorage for the steam yacht *Hauoli II* and the 90-foot racing sloop *Effort II*. A landing dock was added for the captain's gig, and a loading dock was put in for coal and supplies.

Francis Marion Smith, *c.* 1912. F.M. Smith was known as "The Borax King" because he made his fortune hauling borax from his mineral-rich mines in Nevada and California's Death Valley with a twenty-mule team. He is remembered as a warm and personable gentleman.

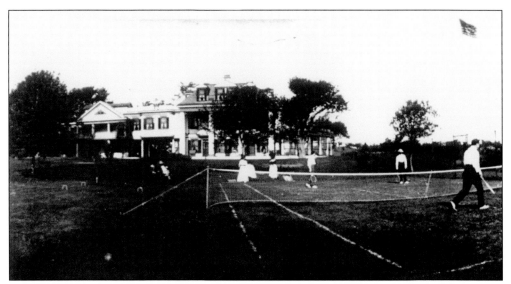

Lawn tennis, c. 1910. A court was laid out to the east of the Smith house, near the cove, to provide family and friends the enjoyment of playing tennis.

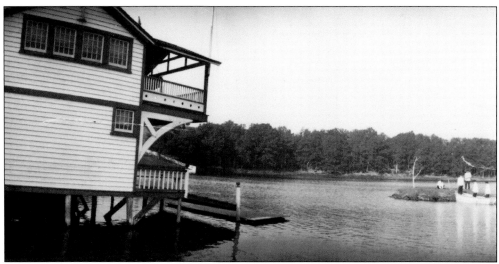

The boathouse on the lagoon, c. 1905. F.M. Smith had a lagoon constructed in order to raise clams, oysters, and crabs for his dinner table. He ordered Cambridge-style punts from England for use in the quiet waters of the lagoon. He had a Japanese-style, arched bridge made to span the inlet. Bathhouses lined the shore, and a float was anchored offshore.

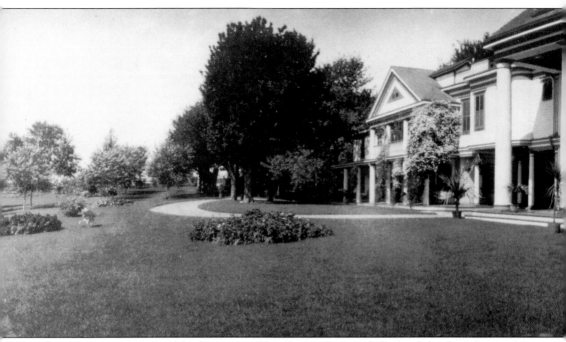

Presdeleau, c. 1900. In 1892, Francis and Molly Smith visited Shelter Island while searching the Atlantic Coast for a suitable summer residence. As they passed the grove where Miss Cartwright's house (built in the early 1700s) was situated, Mrs. Smith declared that the white Colonial home was the one she wanted. The Smiths bought it on the spot. Elias Havens Payne

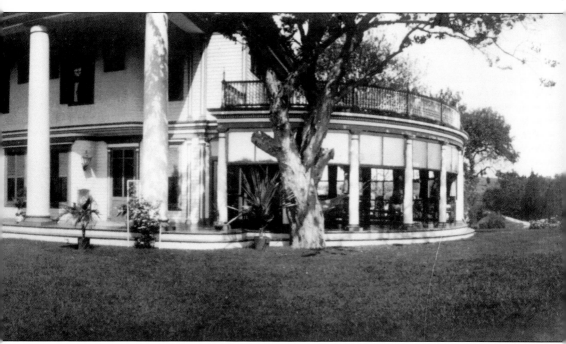

built an extension onto the house. He placed four great columns along the porch in a graceful semi-circle to match the pillars of the Cartwright house. The dining and living room interiors were richly paneled with oak. The Smiths entertained many house guests, who were easily accommodated in the thirty-five bedroom mansion.

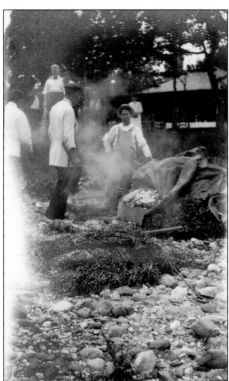

A clambake at Cedar Island, c. 1906. Clambakes were all-day events, beginning with the gathering of rocks and baskets of seaweed for the shallow pit. Plenty of clams and food wrapped in cheesecloth were prepared for the bake. The pit was covered and the food allowed to cook for hours.

A picnic in October 1905. Following this excursion on Ram Island, the Smith family enjoyed a

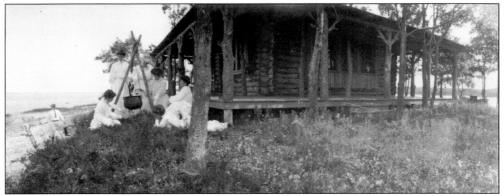

A log cabin, c. 1904. The cabin at Cedar Island was a place of picnics, clambakes, and overnight camp-outs. The swimming was ideal in Cedar Island Cove, located on the northern shore of Mashomack Preserve.

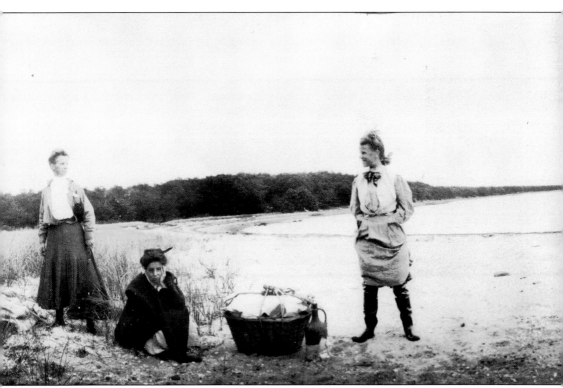

relaxing day on the beach.

West Neck Park, c. 1895. John L. Nostrand bought approximately 1,000 acres of land on the west side of the island in 1883. The property line ran from Ice Pond to Crescent Beach (excluding Stern's Point) and included all of West Neck and Silver Beach. In the late 1800s, a number of houses were built along Nostrand Parkway overlooking Peconic Bay.

Nine

West Neck Park

On the lawn of the Nostrand House, *c.* 1904. Mrs. Benjamin Arcularius, Ella Frances (Arcularius) Nostrand, and Elizabeth Nostrand were photographed on the lawn of the Nostrand home. The home was built by Peter Elbert Nostrand on 4 acres of land, situated on 400 feet of shorefront.

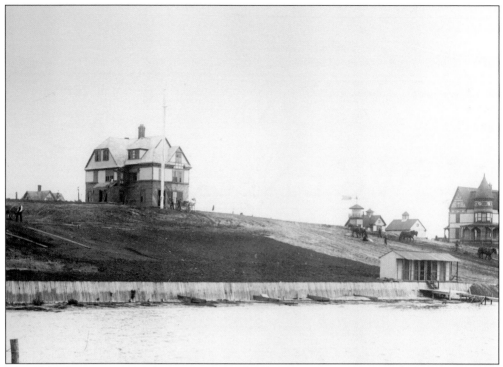

The Weber house, c. 1890. The impressive Weber house was erected in 1889 by William Ulmer, a well-known brewer from Brooklyn, for his daughter, Mrs. John W. Weber. He also built a house nearby for another of his daughters, Mrs. John F. Becker. The Becker farmhouse, pictured in the rear, is on Belvidere Avenue.

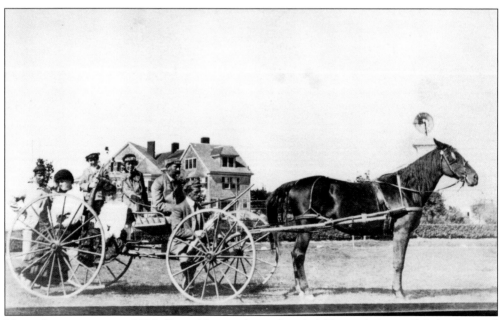

Horse-drawn wagon, c. 1904. Peter Nostrand posed with Mike and Agnes Sabalauskas and family in front of the Weber house.

On the Nostrand dock in 1904. Elizabeth Nostrand was joined by her cousin, Elinor, and the Ruthman girls on the dock in front of her house.

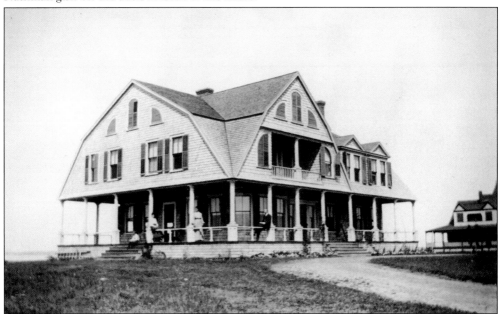

The Nostrand residence, c. 1900. In 1883, John Nostrand brought photographers to Shelter Island for the summer to take photographs of the West Neck area. They stayed beside Inside Bay (West Neck Bay) in a tent, which they used for developing the prints. Mr. Nostrand had maps drawn up, roads built, and advertising brochures written as he divided the land into lots to sell.

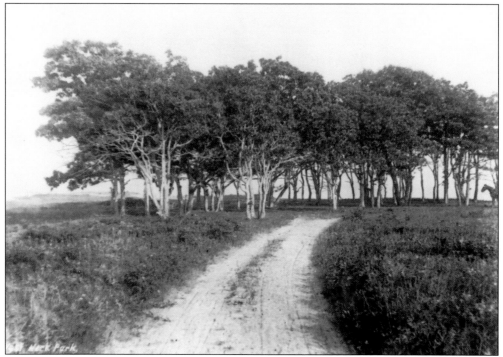

Shell Beach, *c.* 1890. To reach Shell Beach, one had to cross over the flat land thickly covered with blackberry briars, which became known as Silver Beach. It was far more accessible by boat. In those days, the narrow spit of land extended only a short distance into the water; however, at low tide, mud flats could be reached by wading through ankle-deep water.

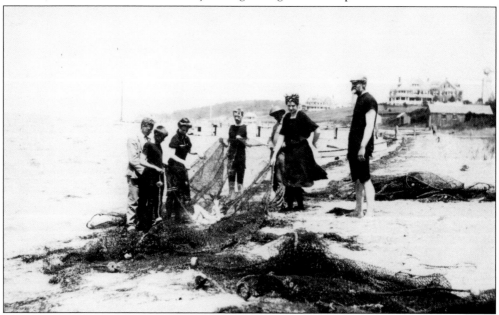

Hauling the seine in 1904. A cheerful-looking group hauled in a net on the Nostrand Beach. The launch, *Ella*, was stored in the small boathouse (pictured on the shore) in winter. The bearded man with a cap is Peter Nostrand.

Racing in the harbor, *c.* 1940. Quick "lightnings" raced toward the buoy in a summer regatta. Larger sailing vessels, launches, and steamers could be watched from the broad open porches of the Nostrand Parkway estates, as they traversed Peconic Bay.

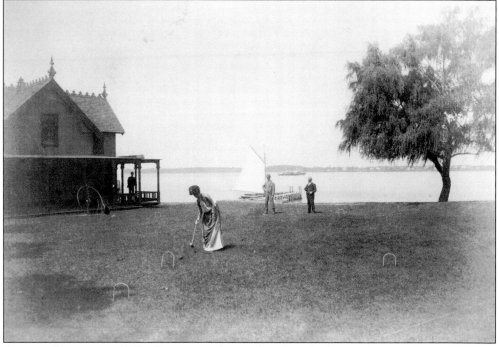

A game of croquet, *c.* 1890. Croquet was being played on the lawns of private homes, rooming houses, and resort hotels as the game rapidly gained popularity.

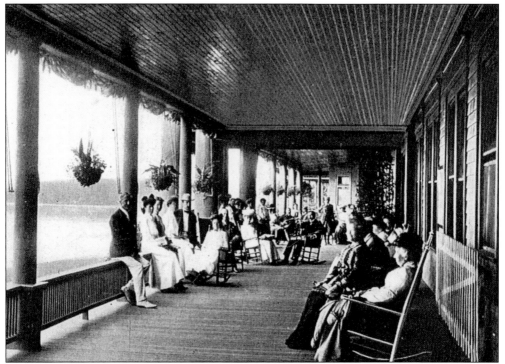

The Manhanset House veranda, *c.* 1890. A magnificent panoramic view of Greenport Sound and the harbor could be enjoyed from the broad, shady porches of the Manhanset House.

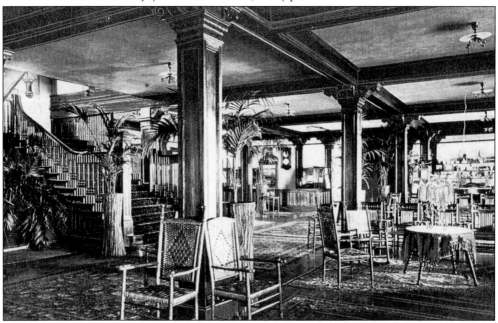

The Palm Room, *c.* 1889. The 76-foot dining room was reported to be one of the largest and finest on the East Coast. While most of the hotel and the cottages were lit by gas, the dining room, parlors, and halls had electric lights as early as 1884. Communication with the front desk was achieved by the use of a signal bell and talking tube. Steam provided heat.

Ten

The Manhanset House

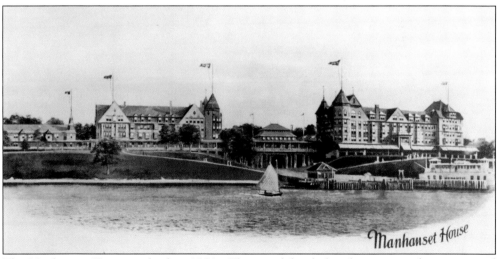

The Manhanset House in the late 1800s. The grand family hotel was situated on a terraced bluff overlooking Dering Harbor and Greenport Channel. Two hundred acres at Locust Point had been purchased from the Sylvester Estate in 1872. A development corporation was formed with Erastus Carpenter (the originator of the Oak Bluffs Camp Meeting colony on Martha's Vineyard) as its president. The plans for Shelter Island Park included the large hotel, seaside cottages, docks, and entertainment facilities.

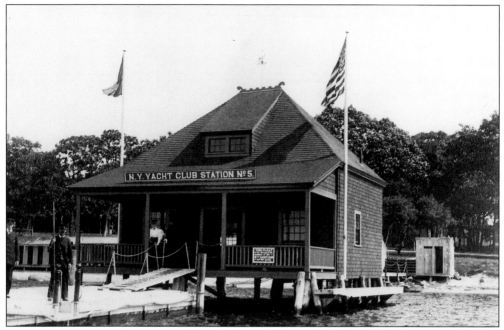

New York Yacht Club No. 5, *c.* 1895. At the southern end of the Manhanset House bathing beach was the clubhouse of the New York Yacht Club. The fleet was regularly anchored in Dering Harbor. Signal flags were raised each day to report the weather forecast, which was wired from Washington, DC.

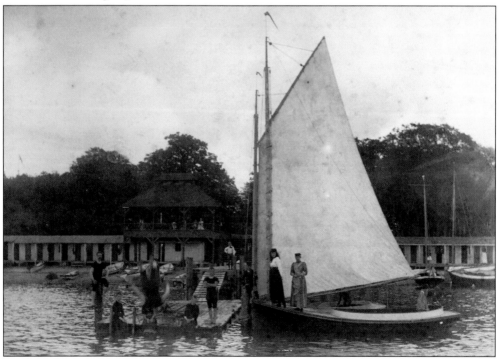

The bathing dock, *c.* 1885. Manhanset House maintained a long string of bathhouses along the Dering Harbor shore, away from the steamer docks and strong tidal currents.

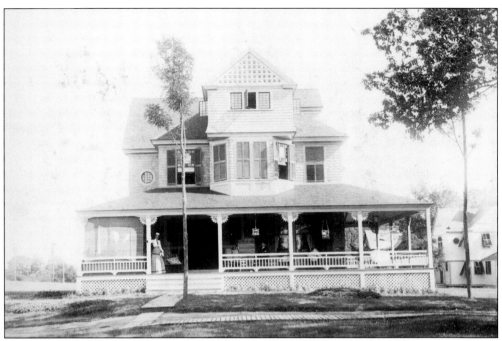

A seaside cottage, c. 1890. In the groves of Shelter Island Park, a small cottage community was built in the Victorian style.

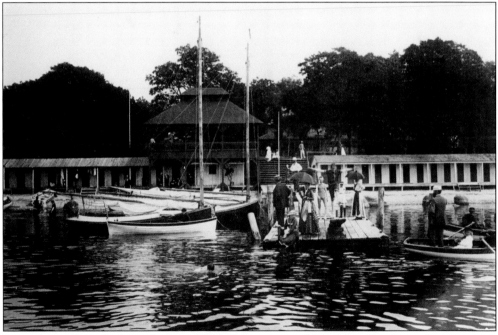

Swimming off the bathing dock, c. 1885. Swimming and boating were the main attractions of the summer resort, but many other activities were enjoyed. Lawn tennis, archery, baseball, billiards, bowling, golf, and croquet were offered for the more competitive guests. Others were entertained with orchestral concerts, ballroom dancing, hops, clambakes, picnics, and ice cream socials. The pavilion pictured above offered tea and music.

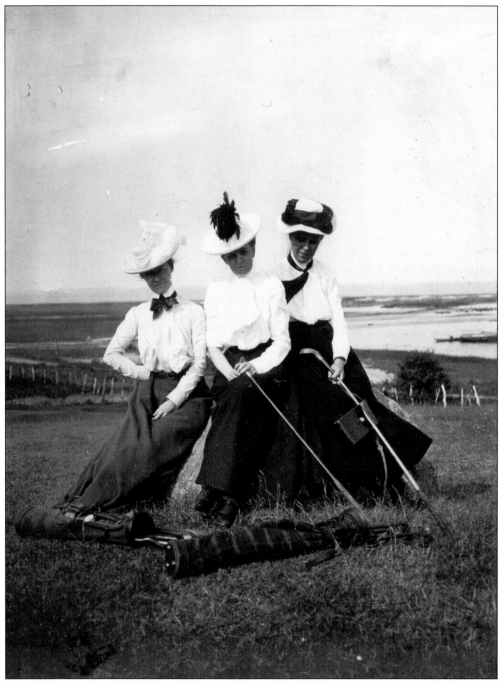

A golfing trio, *c*. 1888. Nine holes were laid out in the same area as the present course at Gardiner's Bay Country Club. Golfers teed off from the Dering farmhouse, which served as a clubhouse for the Manhanset House guests who were eager to play the game of golf, which had been recently brought to America.

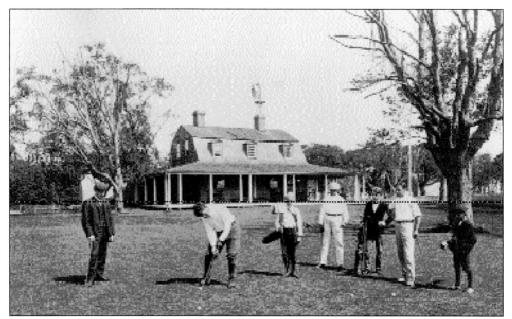

Dering Harbor Golf Club, c. 1900. The first clubhouse was the Colonial home of Thomas Dering, which was built about 1770. Attendants to carry the golf sticks were hired at 10¢ per boy. Loren Littlefield is the caddy to the left in the above photograph. Gardiner's Bay Country Club, as it was later renamed, has the distinction of being the third oldest golf club in the nation. In 1906, the course was expanded to include eighteen holes.

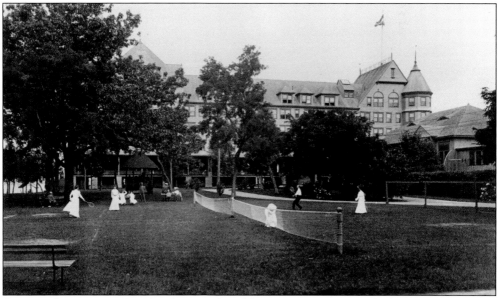

A game of tennis, c. 1904. Hotel guests played lawn tennis on courts which were positioned in 1904 behind the second Manhanset House.

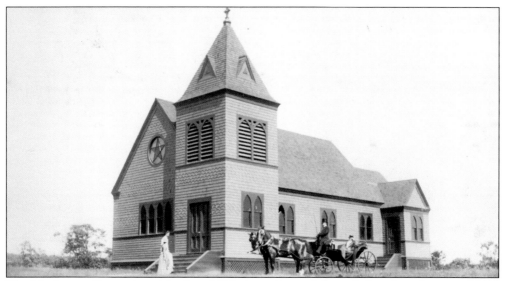

The Manhanset House chapel, built in 1890. A sturdy wood-framed chapel was built on a quiet hill behind the prosperous hotel. Non-denominational services were said by visiting clergymen. After the Manhanset House was destroyed by fire in 1910, artist Milton Bancroft bought the chapel for use as a studio. He replaced the rose window with a large Gothic-style arched window to capture the northern light. The building was moved on rollers, using teams of horses, in 1924. It took eight weeks to complete the job. The Junior Order of United American Mechanics utilized the steepled chapel as a meeting hall for over forty years. It was acquired by the Shelter Island Historical Society in 1985, functioning as the Manhanset Chapel Museum.

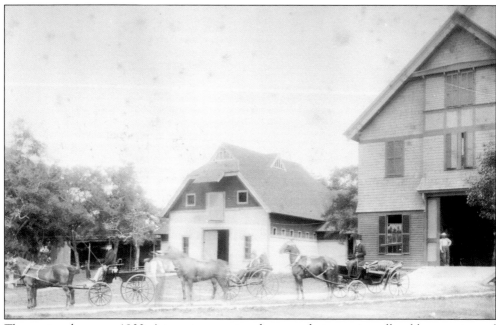

The carriage house, c. 1900. A two-story carriage house and ninety-six stall stable were situated to the south of the hotel. Guests enjoyed carriage rides along the rural dirt roads of Shelter Island, stopping at areas of business, as well as scenic locations.

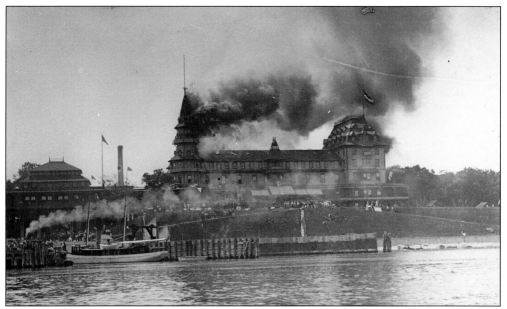

The Manhanset House fire, August 13, 1896. The Manhanset House was destroyed during the morning hours of a breezy summer day. The blaze, which started in the laundry room behind the hotel, quickly engulfed the main building. The establishment was filled to capacity with over three hundred guests; luckily, everyone escaped the fire. Hotel manager Lawson did suffer injuries. The new Manhanset House was quickly built, but on May 14, 1910, a bolt of lightning struck the hotel and sent the buildings up in flames.

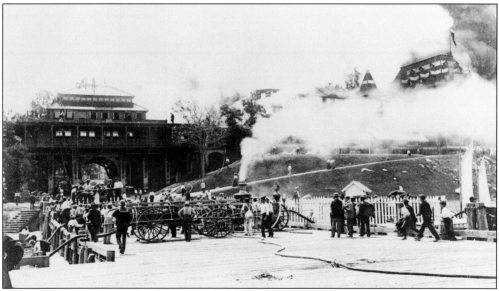

Firefighters battling the blaze in 1896. Men and equipment were rushed from Greenport to Shelter Island to assist the local firemen in their attempt to control the rapidly advancing flames at the Manhanset Hotel. A brief attempt to cut the "bridge" leading to the new annex had to be abandoned in favor of stationing men wrapped in wet blankets on the roof to fight the blaze. Scores of volunteers manned the bucket brigades, while hoses spewed salt water from the bay onto the burning structures.

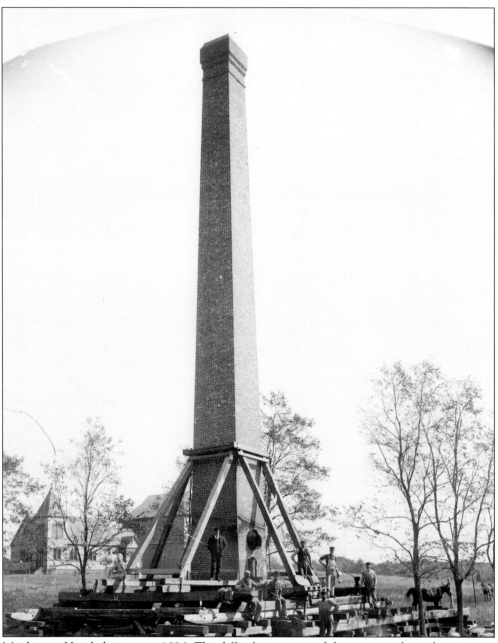

Manhanset Hotel chimney, *c.* 1896. The difficult transport of the great smokestack to its new location beside the reconstructed laundry building was accomplished by Hopping and Topping of Bridgehampton.

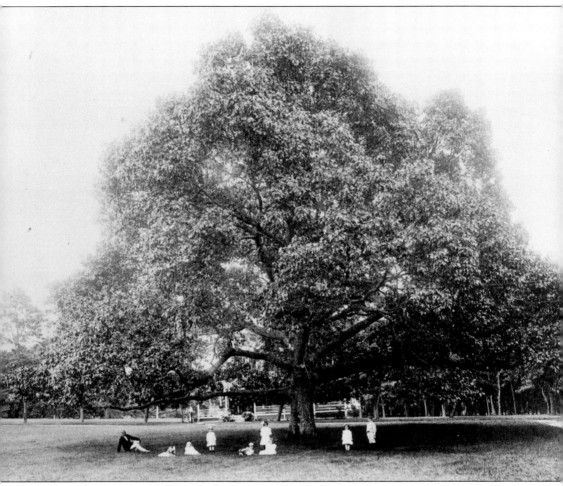

The Great Oak, *c.* 1904. The circumference of the huge native oak tree that grew amid the Manhanset cottages measured 90 feet when it was suddenly uprooted by the 1938 hurricane. There is no doubt that the mighty, sheltering tree had been in existence when the Manhanset Indians lived in the peaceful woodlands of Shelter Island.

DISCOVER THOUSANDS OF LOCAL HISTORY BOOKS FEATURING MILLIONS OF VINTAGE IMAGES

Arcadia Publishing, the leading local history publisher in the United States, is committed to making history accessible and meaningful through publishing books that celebrate and preserve the heritage of America's people and places.

Find more books like this at
www.arcadiapublishing.com

Search for your hometown history, your old stomping grounds, and even your favorite sports team.

Consistent with our mission to preserve history on a local level, this book was printed in South Carolina on American-made paper and manufactured entirely in the United States. Products carrying the accredited Forest Stewardship Council (FSC) label are printed on 100 percent FSC-certified paper.

MADE IN THE USA